LANDSCAPE AUSTRALIA

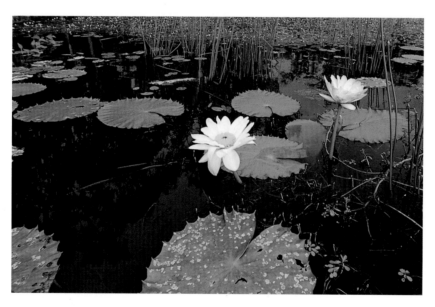

First published in Australia in 2006 by Reed New Holland
an imprint of New Holland Publishers (Australia) Pty Ltd
Sydney • Auckland • London • Cape Town
1/66 Gibbes Street Chatswood NSW 2067 Australia
218 Lake Road Northcote Auckland New Zealand
86 Edgware Road London W2 2EA United Kingdom
80 McKenzie Street Cape Town 8001 South Africa

2 4 6 8 10 9 7 5 3

National Library of Australia Cataloguing-in-Publication Data:

Landscape Australia.

ISBN 9781877069345 (hbk.).

1. Landscape - Australia - Pictorial works. 2. Australia -
Pictorial works. I. Silvana, Yani.

919.400222
Publisher: Martin Ford
Project Editor: Yani Silvana
Designer: David Beattie
Production: Linda Bottari
Printer: Everbest Printing Co., China

FRONT COVER : *The dazzling white quartz sand of Whitehaven
Beach on uninhabited Whitsunday Island off Queensland.*
TITLE PAGE : *Waterlilies in Daintree National Park, Queensland.*
OPPOSITE : *The huge monolith Uluru towers more than 300 m
above the surrounding plains in the heart of Australia. It is of
great spiritual significance to the Anangu Aboriginal people.*

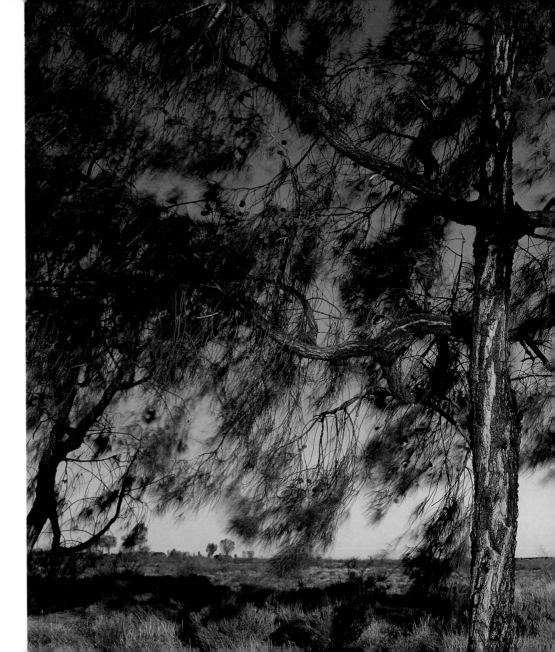

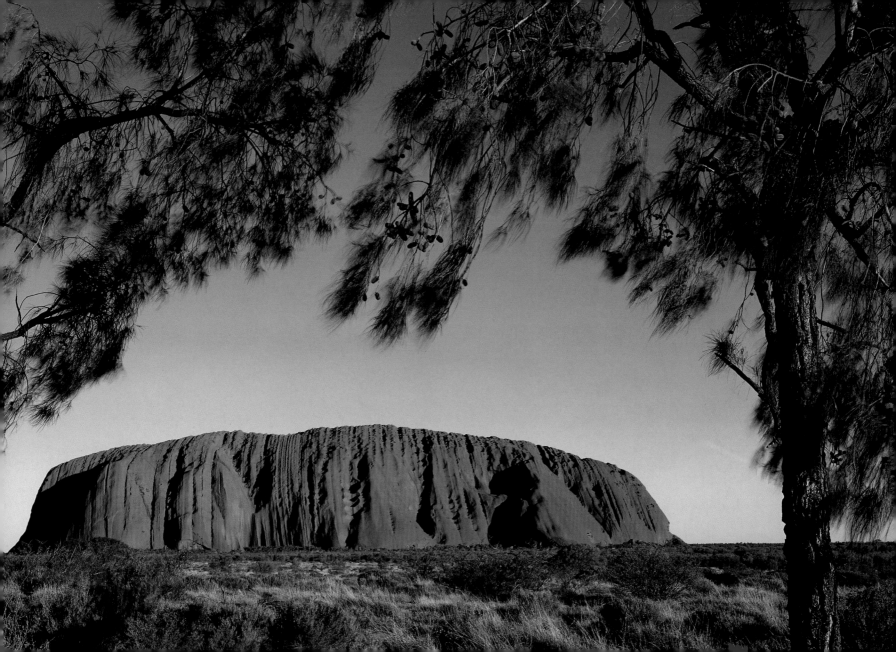

INTRODUCTION

Once part of the southern supercontinent of Gondwana, Australia separated from Antarctica and South America 40 million years ago. Its subsequent isolation has resulted in the evolution of a unique and diverse collection of plants and animals, while weathering and erosion has given rise to spectacular rock formations, gorges and deserts, coloured in rich reds, browns and ochres. *Landscape Australia* features all of this diversity. It also includes Aboriginal sites dating back up to 40 000 years, such as at Lake Mungo in western New South Wales and artwork in rock shelters in the Northern Territory.

Also featured are some of Australia's sixteen separate World Heritage sites, including Uluru–Kata Tjuta National Park, Fraser Island, the Tasmanian Wilderness, Kakadu National Park and the Wet Tropics of Queensland.

For those who enjoy the natural world, here is a book to either inspire you to take to the road and see this ancient and beautiful country—its national parks, plants and animals—or to keep or give as a souvenir of your travels.

RIGHT : *The jagged silhouette of Cradle Mountain forms a backdrop for the tranquil waters of Dove Lake in Tasmania's Wilderness World Heritage Area.*

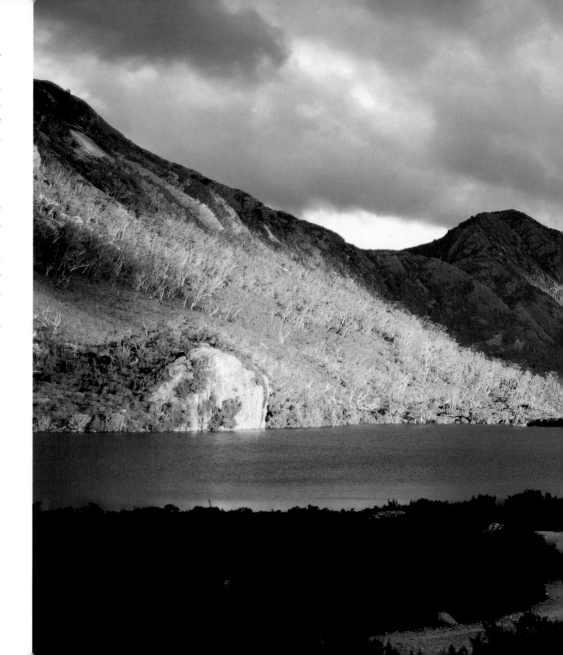

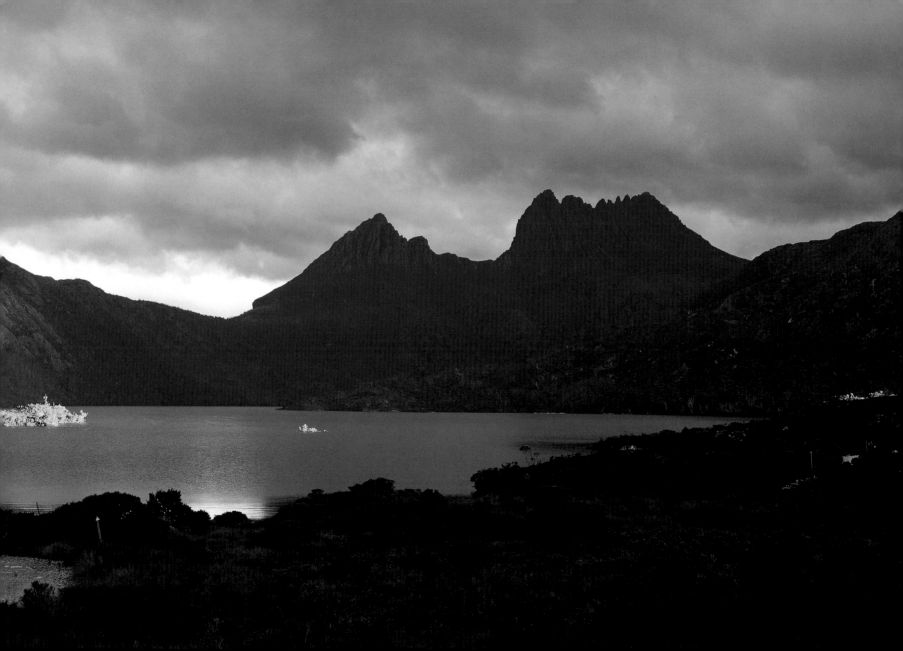

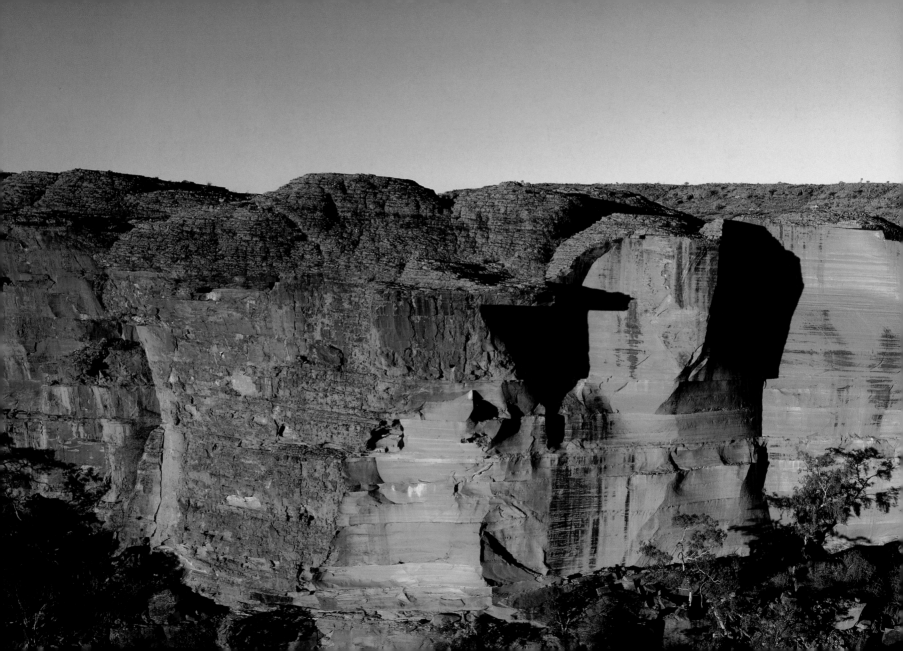

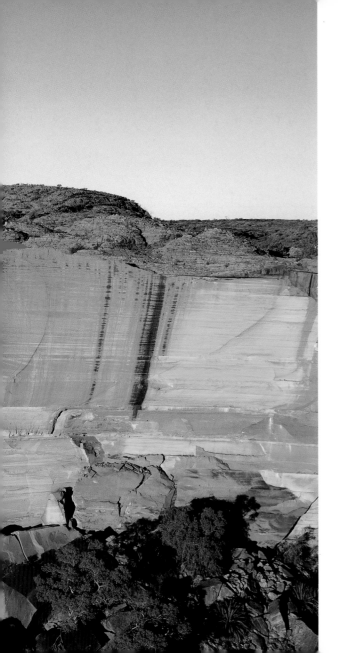

LEFT : *The rugged walls of Kings Canyon in central Australia. Within the canyon are cool waterholes and a huge variety of wildlife and plants.*
RIGHT : *Sturt's Desert Pea is one of Australia's best known desert wildflowers.*

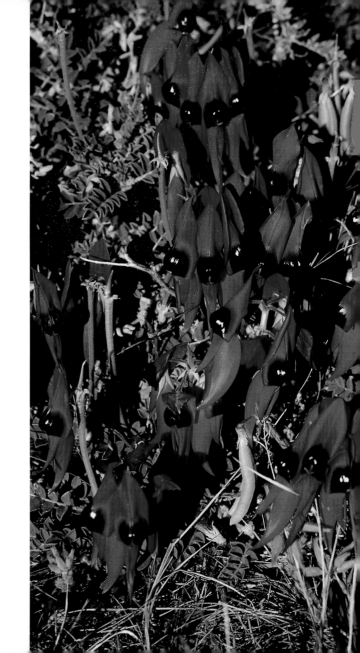

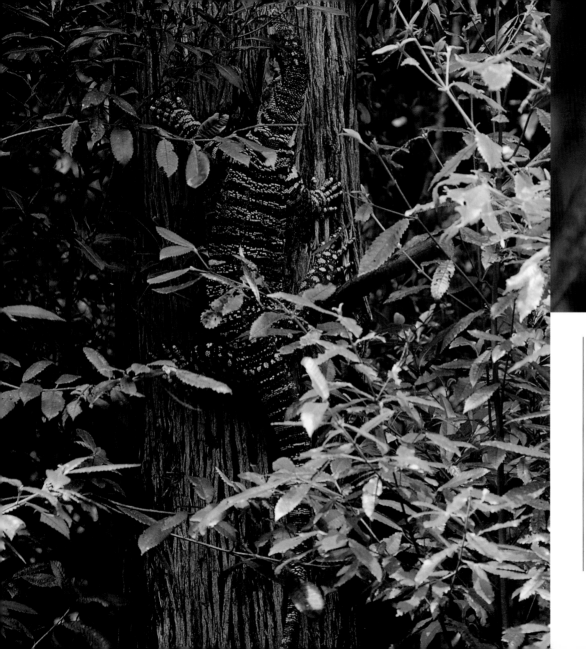

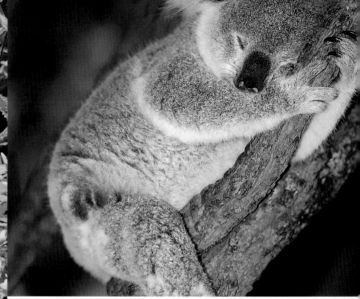

LEFT : *A large goanna blends into its surroundings on the trunk of a tree.*
ABOVE : *The koala is one of the few animals that can survive on a diet of only gum leaves, but their slow metabolism means that they sleep for up to 18 hours a day.*
RIGHT : *Its banks lined with eucalypts, the Murrumbidgee River in New South Wales has long been an important part of the irrigation scheme for the crop-growing Riverina district. Many species of fish, including the famous Murray Cod, live in the river.*

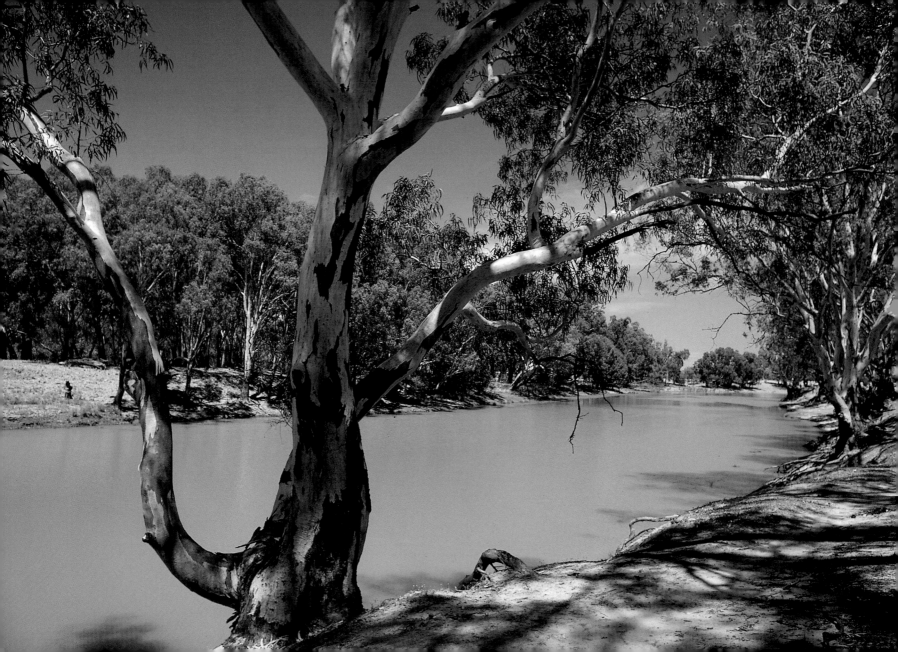

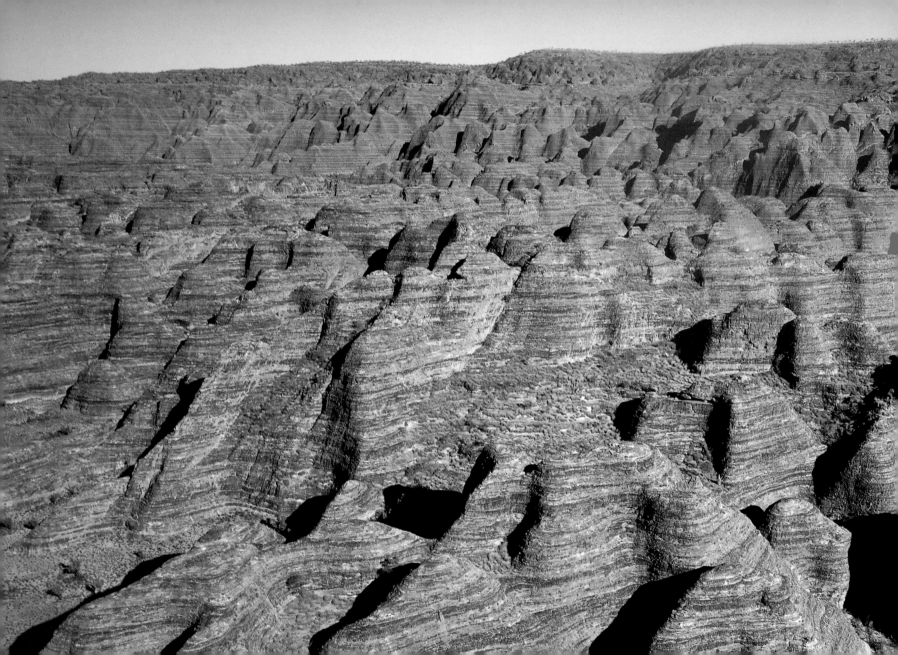

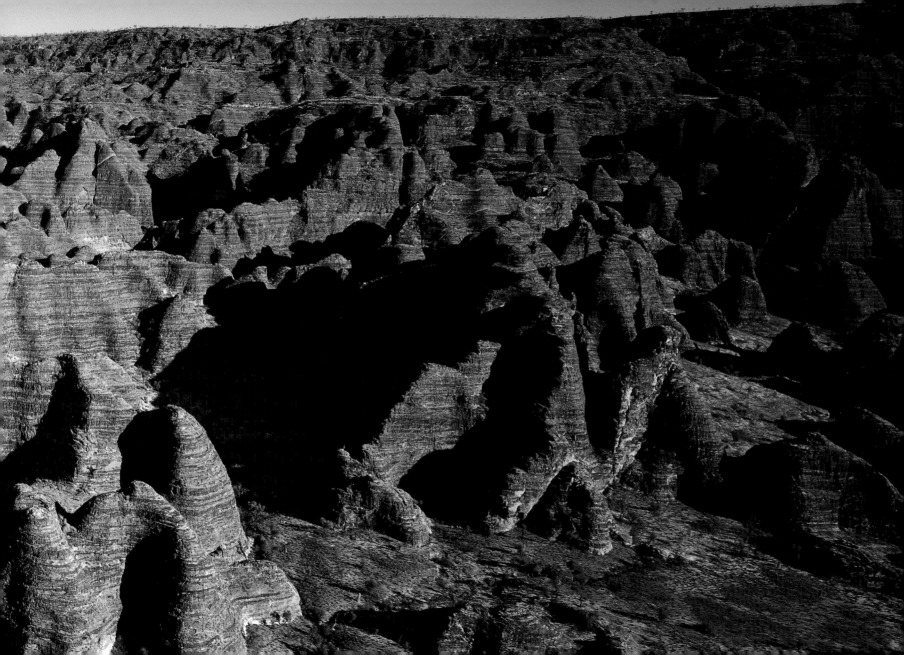

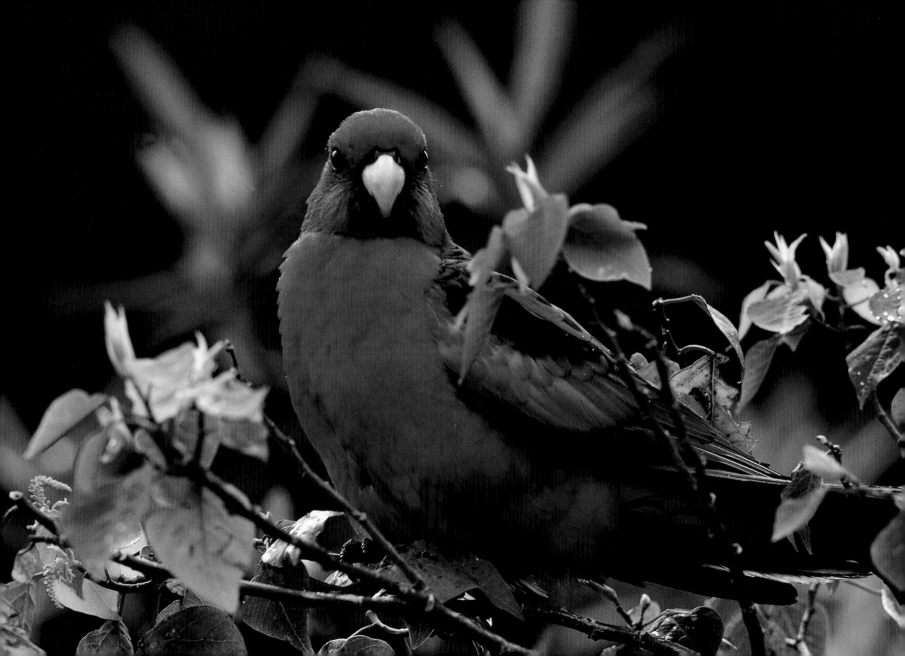

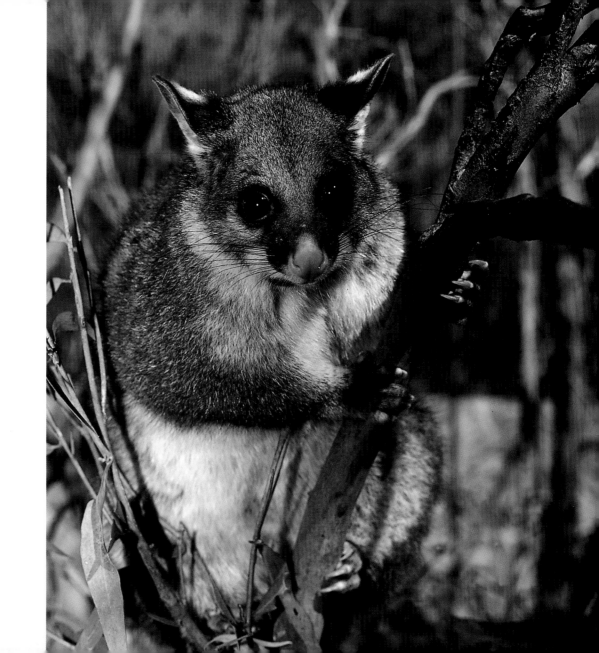

PREVIOUS PAGE : *Twenty million years of erosion have created the spectacular sandstone Bungle Bungle Range in Western Australia's Purnululu National Park. The coloured bands are formed of different types of rock.*

LEFT : *The beautiful Crimson Rosella is one of many colourful species of parrots in Australia. They feed on the ground but roost and nest in trees.*

RIGHT : *A bright-eyed possum watches the world go by. These nocturnal creatures are rarely spotted during the day.*

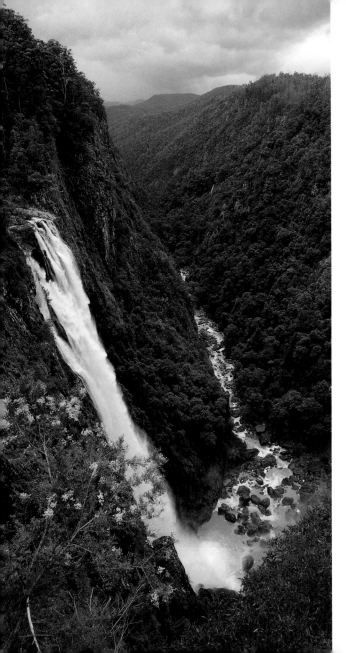

LEFT : *Ellenborough Falls plunges 200 m over the edge of the New England Tableland in New South Wales, and is one of Australia's tallest waterfalls.*
RIGHT : *Deep gorges and rocky spires, dykes and domes make up the ancient volcanic landscape of the Warrumbungles National Park in western New South Wales.*

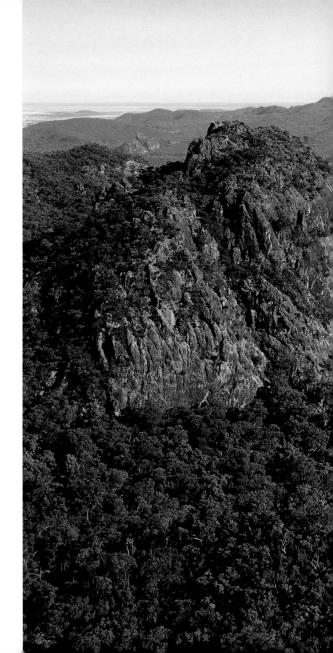

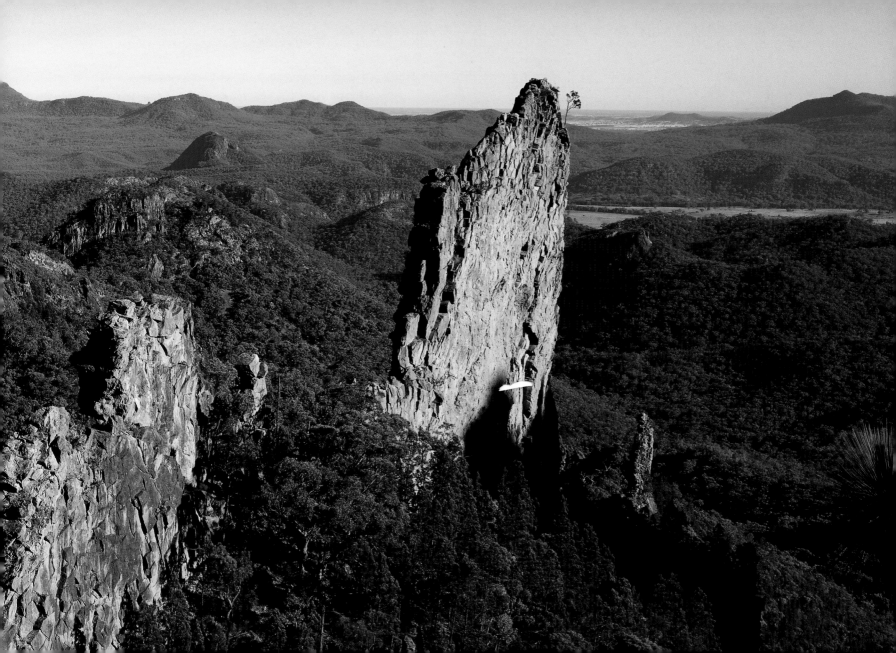

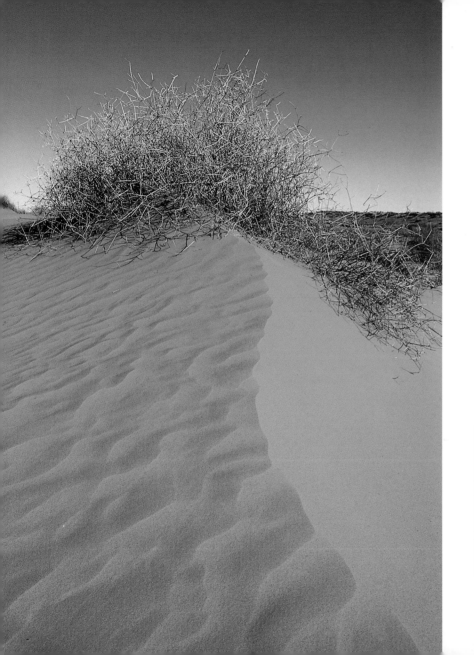

LEFT : *Sand dunes in the Simpson Desert, South Australia. The fine sand is tinted red by iron oxide and was formed into long parallel dunes by the prevailing winds around 40 000 years ago.*

RIGHT : *Lake Poeppel, one of many salt lakes in the Simpson Desert, South Australia.*

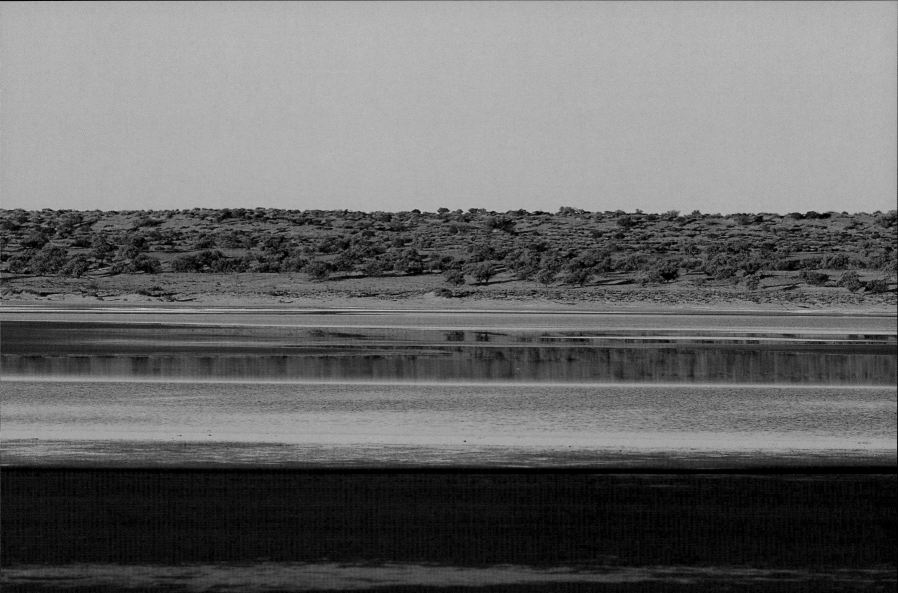

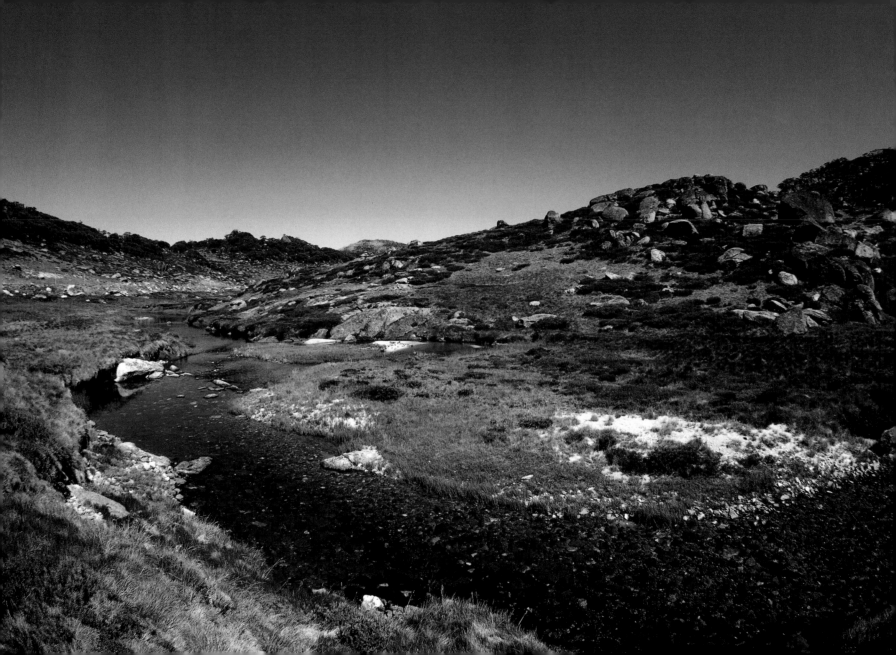

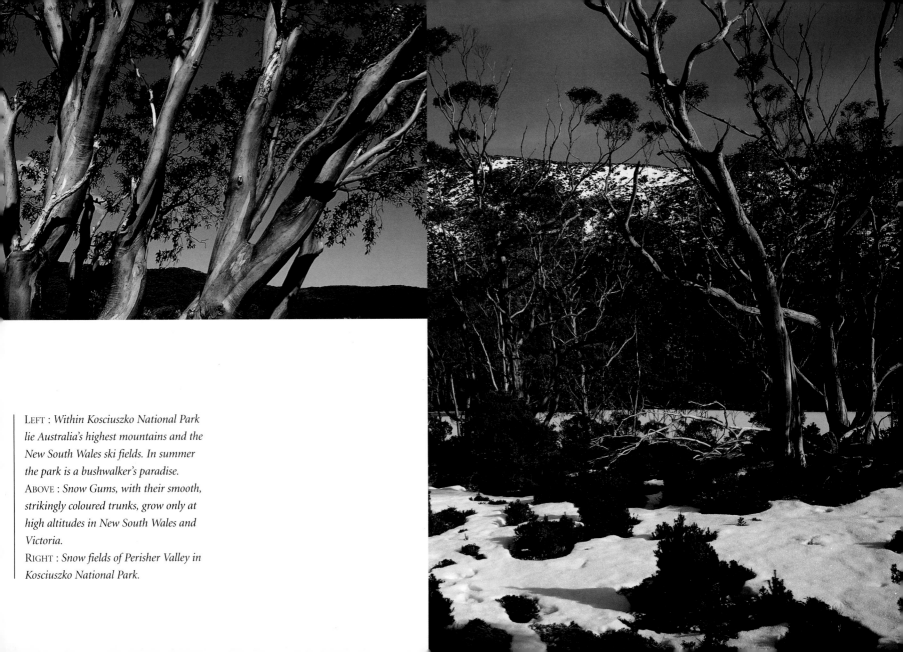

LEFT : *Within Kosciuszko National Park lie Australia's highest mountains and the New South Wales ski fields. In summer the park is a bushwalker's paradise.*
ABOVE : *Snow Gums, with their smooth, strikingly coloured trunks, grow only at high altitudes in New South Wales and Victoria.*
RIGHT : *Snow fields of Perisher Valley in Kosciuszko National Park.*

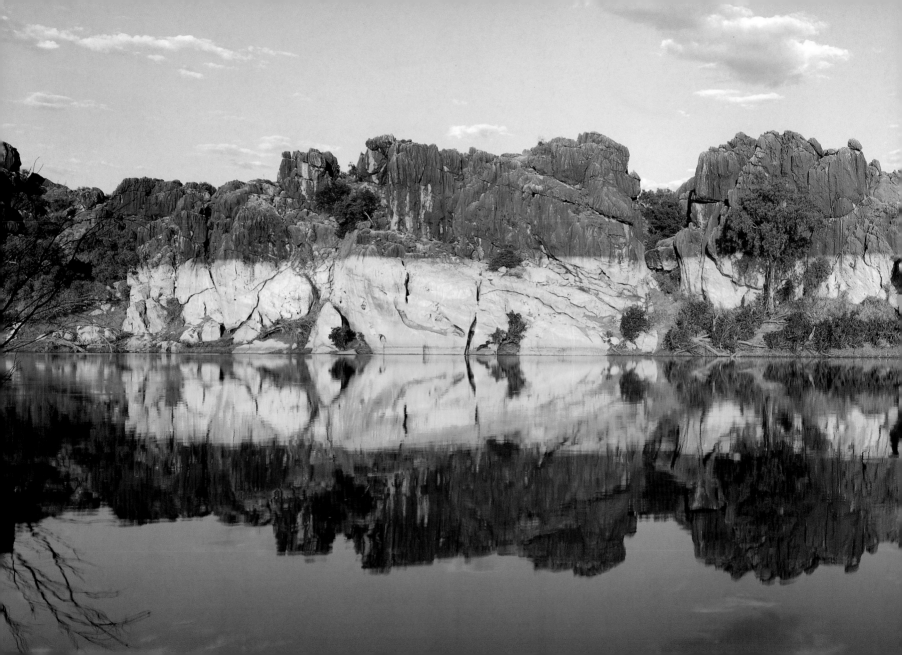

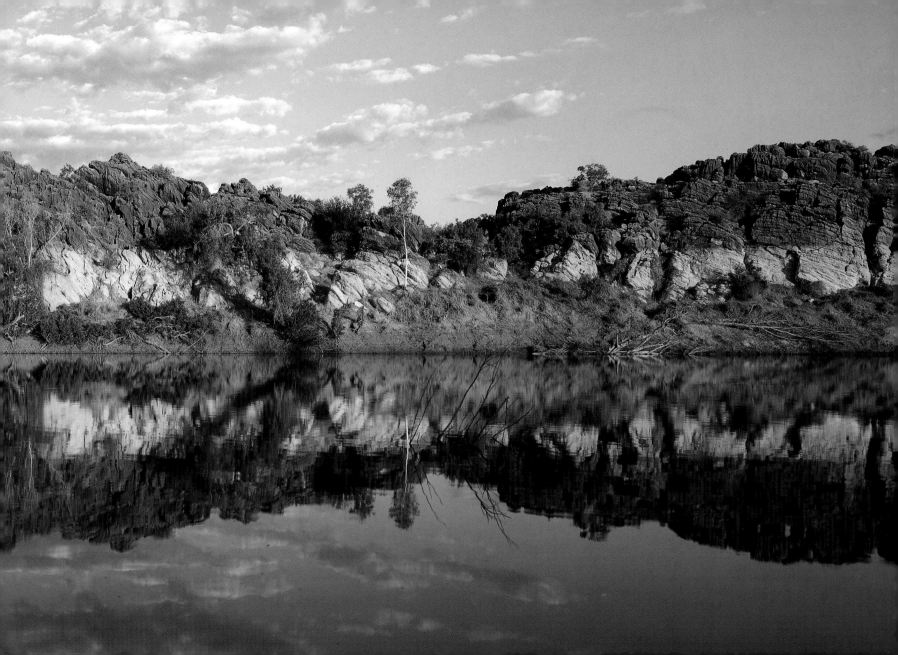

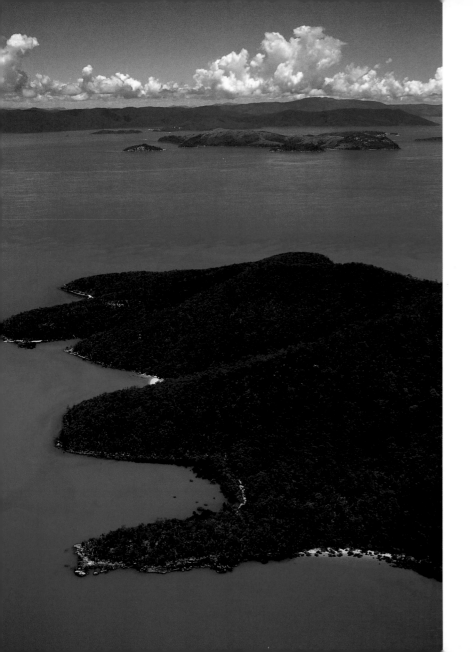

PREVIOUS PAGE : *Geikie Gorge, in Western Australia's far northern Kimberley region, carved through the ancient limestone reef by the Fitzroy River. During the wet season, the river rises more than 16 m, flooding the surrounding plains.*

LEFT : *Islands off the coast of Queensland in the vicinity of the Great Barrier Reef.*

RIGHT : *During summer, female turtles lumber up the beach on Heron Island and other Queensland locations to lay their eggs. Leaving them to incubate deep in the warm sand, they return to the sea. The baby turtles dig their way out of the sand and scuttle down to the water, running the gauntlet of hungry birds and fish. Only a few survive.*

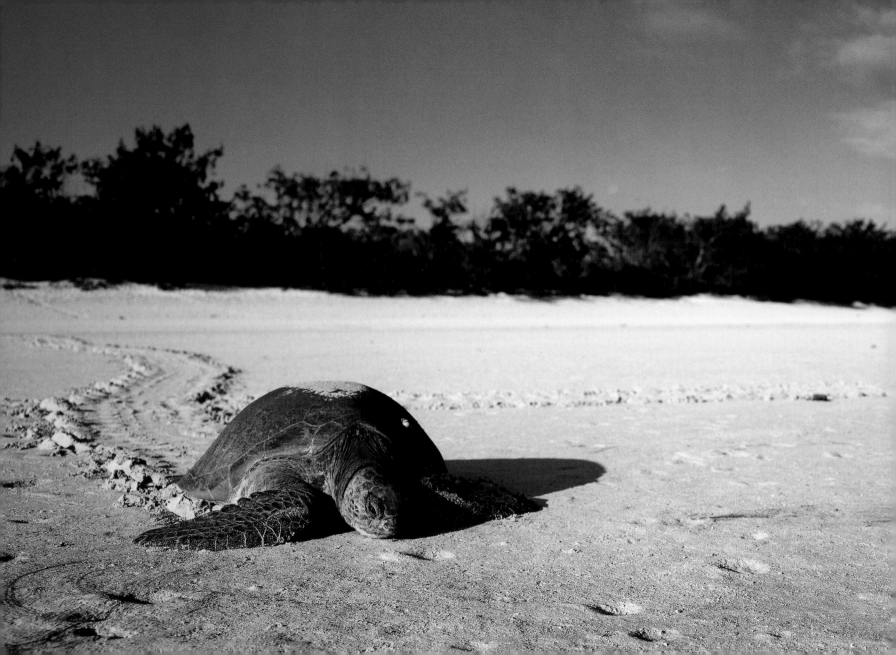

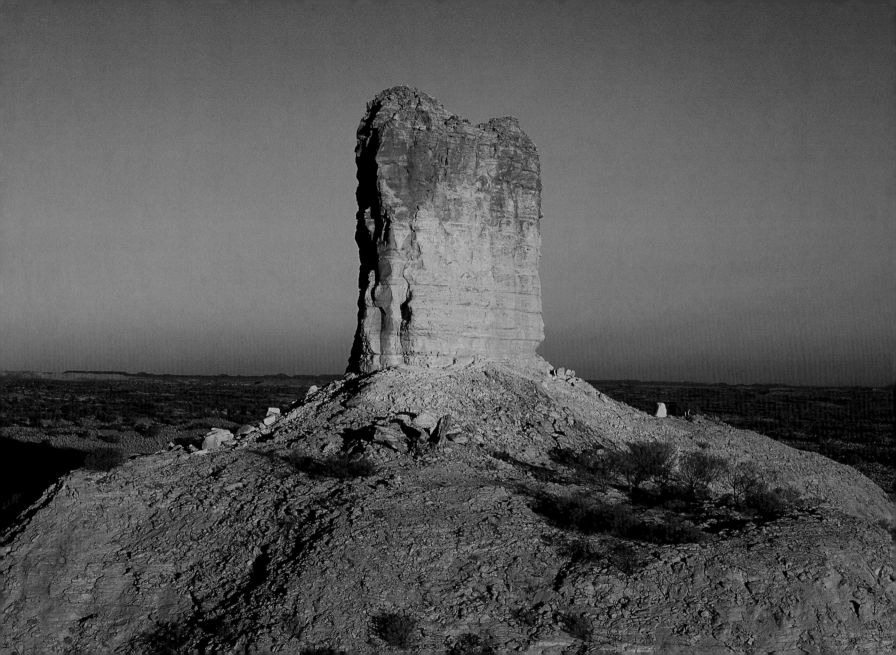

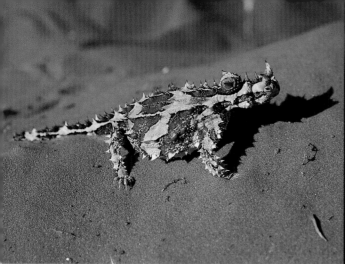

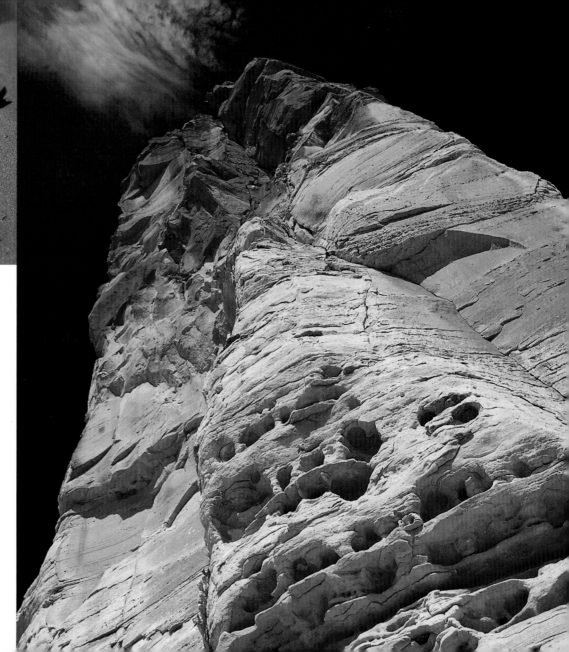

Left and Right : *Chambers Pillar, Northern Territory, in the late afternoon. The pillar was a landmark for early explorers, many of whom carved their names in the rock.*

Above : *The desert-dwelling Thorny Devil walks with a slow, jerky gait and feeds only on black ants.*

Next Page : *Low cloud hangs in the Jamison Valley of the Blue Mountains, near Sydney, with the Three Sisters formation in the foreground.*

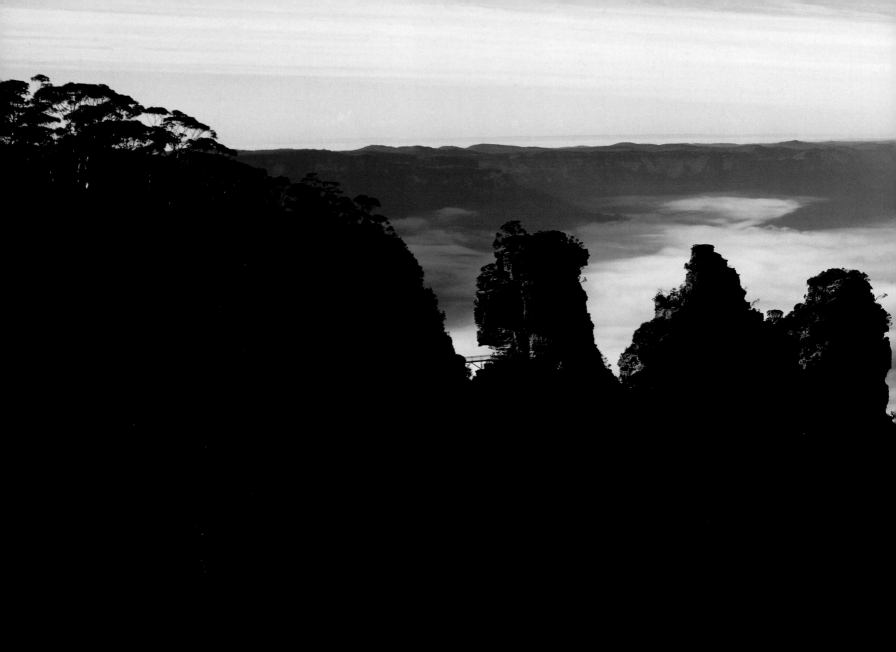

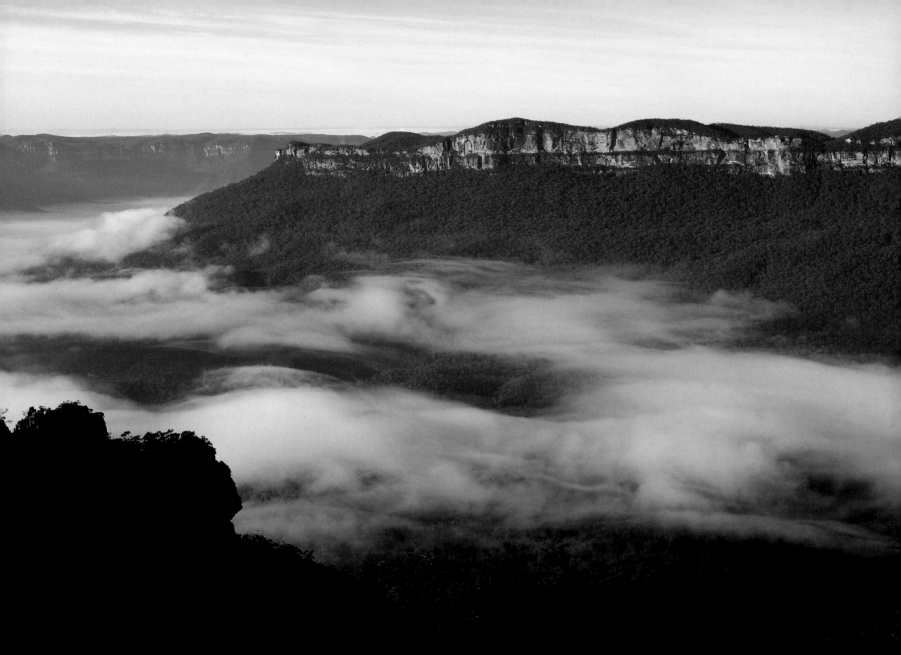

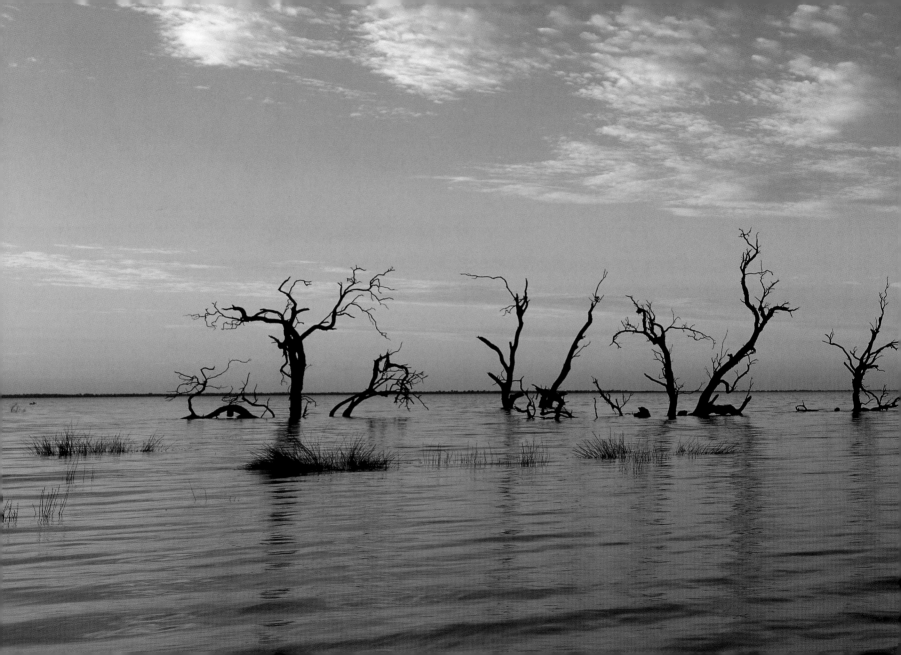

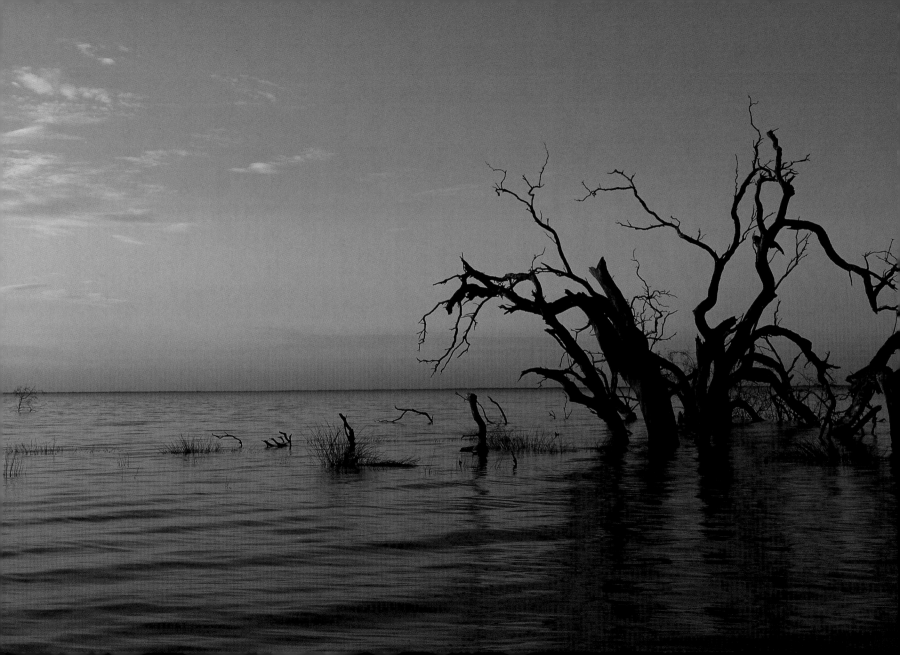

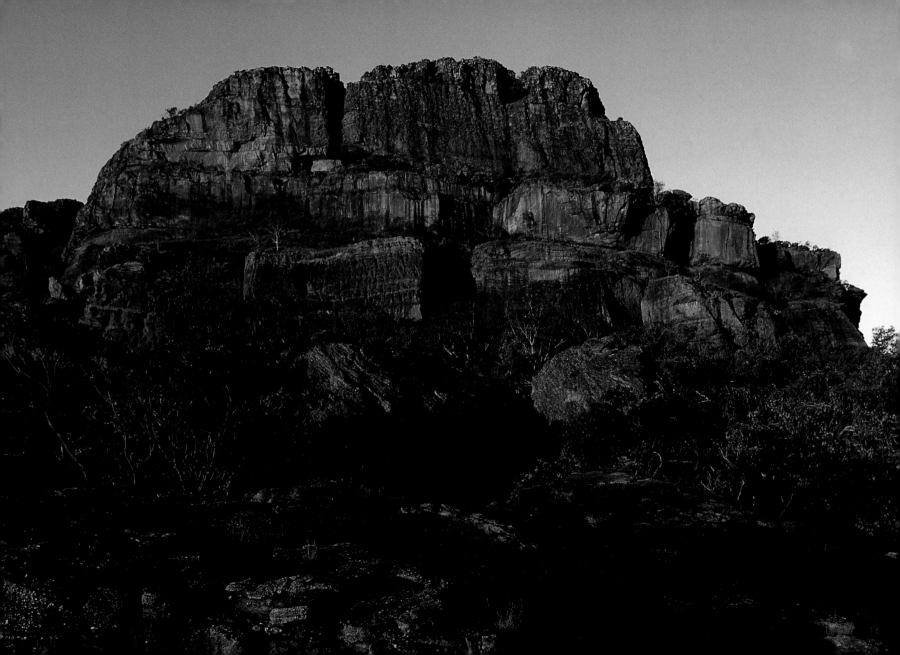

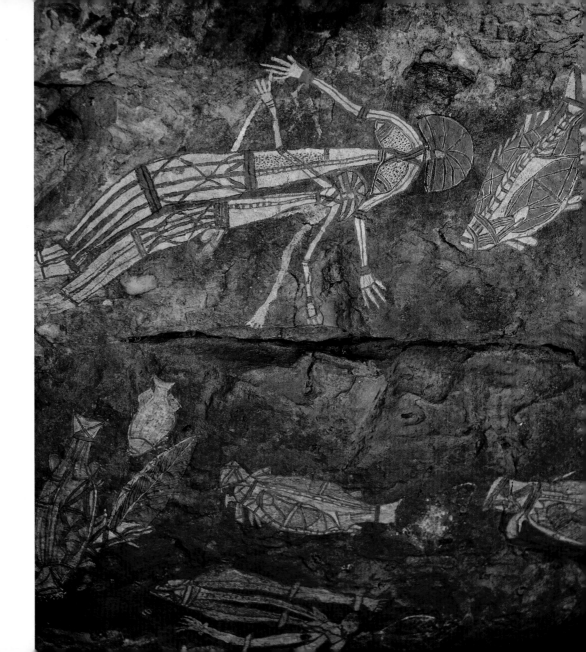

PREVIOUS PAGE : *Drowned forests in the lakes of Kinchega National Park in the otherwise dry heart of western New South Wales. The park is rich in Aboriginal heritage.*

LEFT : *Nourlangie Rock, in the Northern Territory's Kakadu National Park, is rich with Aboriginal sacred sites and paintings.*

RIGHT : *The 'Blue Paintings' near Nourlangie Rock show spirit figures and barramundi fish in the 'x-ray' style of Aboriginal art.*

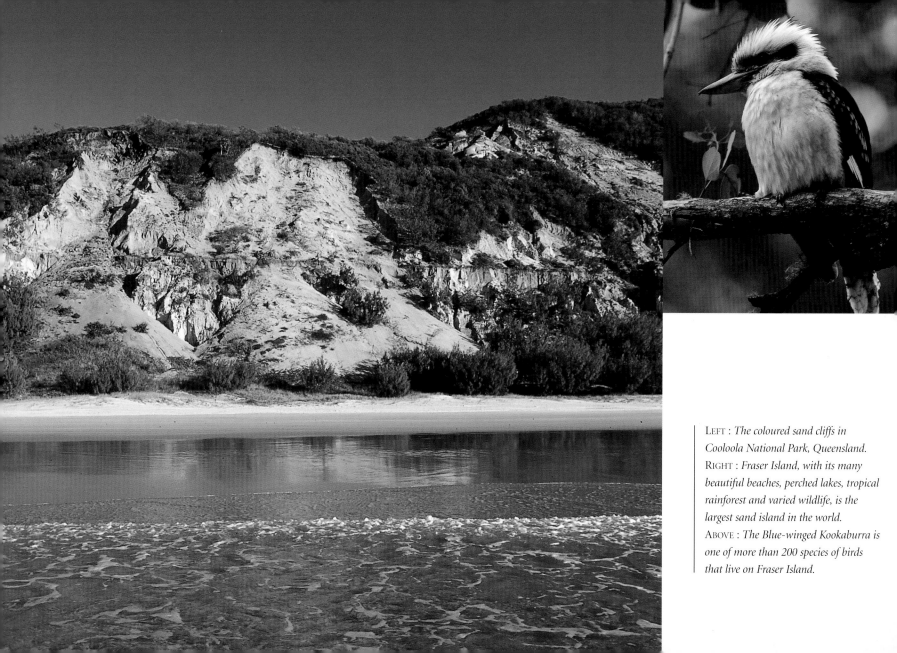

LEFT : *The coloured sand cliffs in Cooloola National Park, Queensland.*
RIGHT : *Fraser Island, with its many beautiful beaches, perched lakes, tropical rainforest and varied wildlife, is the largest sand island in the world.*
ABOVE : *The Blue-winged Kookaburra is one of more than 200 species of birds that live on Fraser Island.*

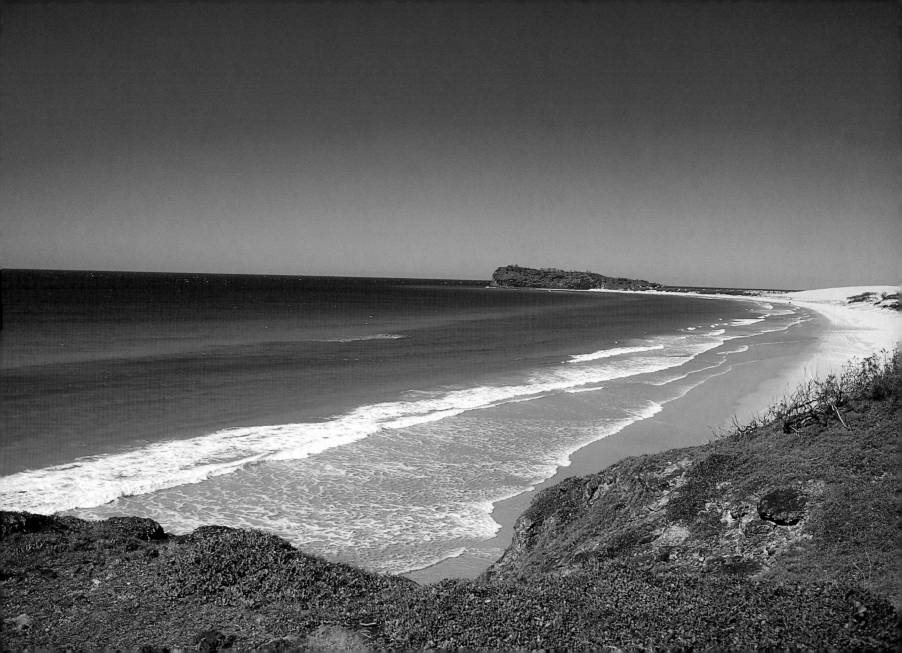

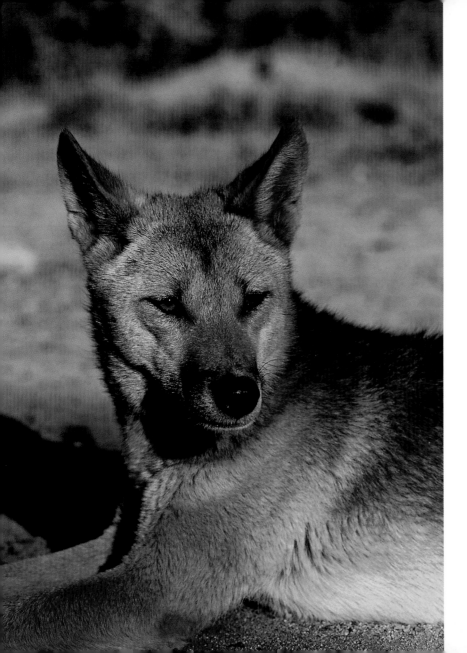

LEFT : *The Dingo is the largest carnivorous mammal in Australia and probably arrived here up to 4000 years ago with Asian seafarers. Dingos howl rather than bark, showing their relationship to wolves.*
RIGHT : *Wave formations in the sedimentary rock in Hamersley Gorge, Karijini National Park, Western Australia.*

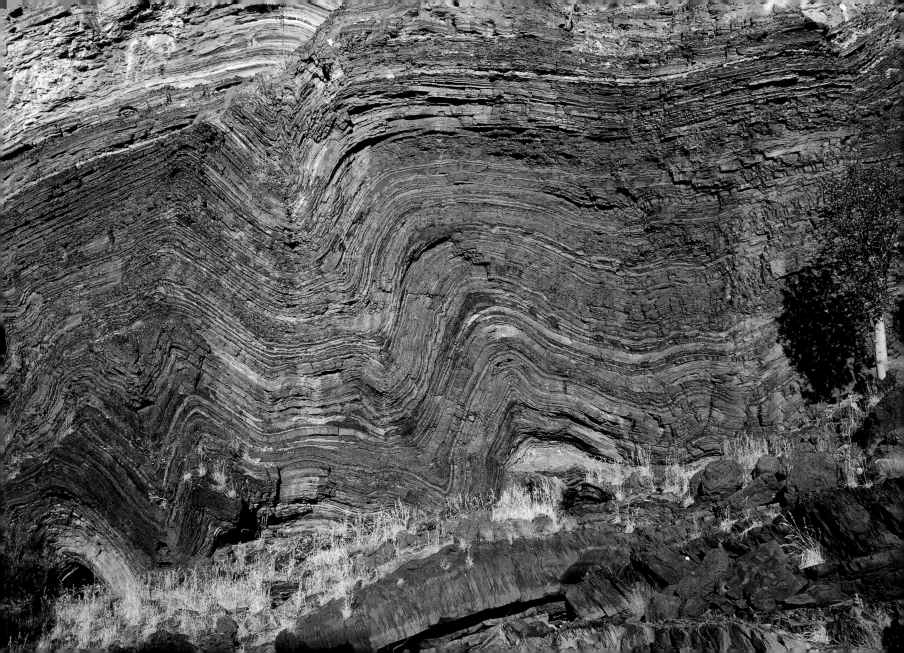

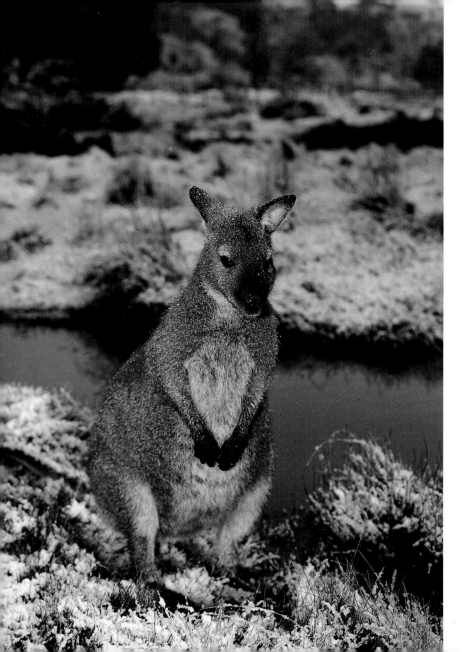

LEFT : *Bennett's Wallabies are common in Tasmania, and are often seen grazing in national parks in the late afternoon and at dusk. On the mainland the same species is known as the Red-necked Wallaby.*

RIGHT : *Twilight snow-covered wilderness in Tasmania's Cradle Mountain–Lake St Clair National Park.*

NEXT PAGE : *The subtropical rainforest of Border Ranges National Park in New South Wales near the Queensland border was once logged for hoop pine, but is now protected by World Heritage listing.*

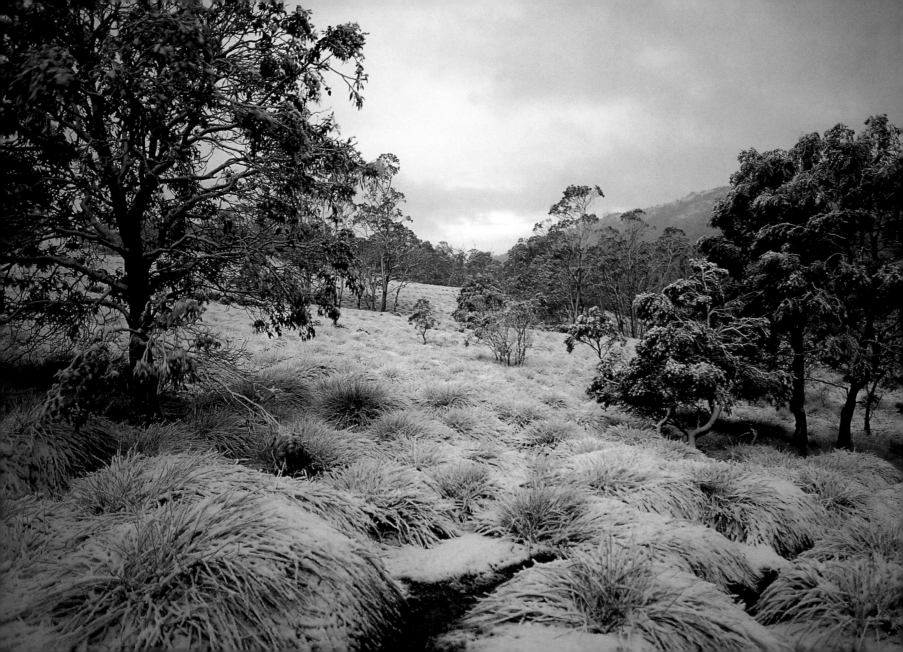

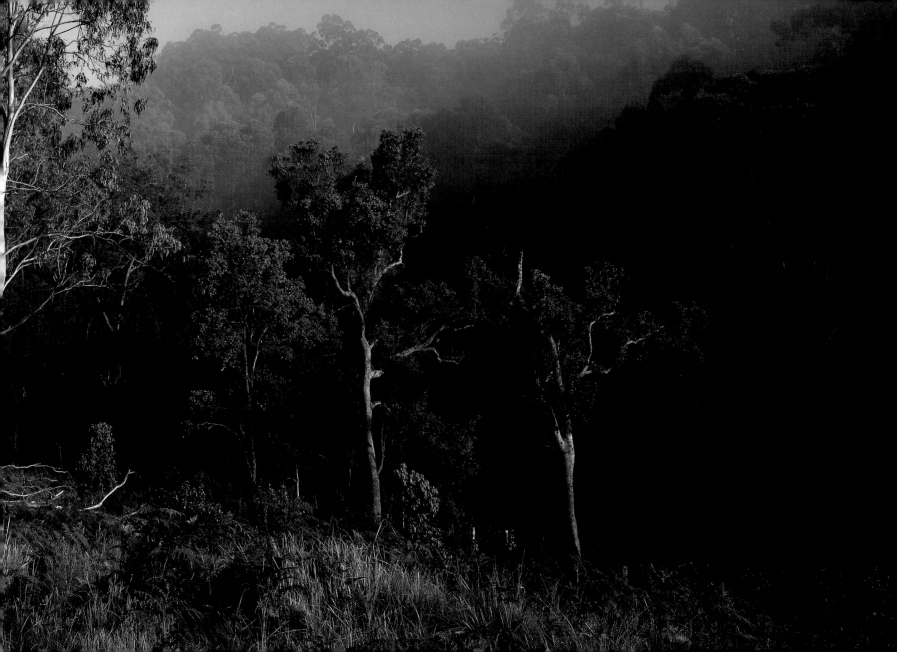

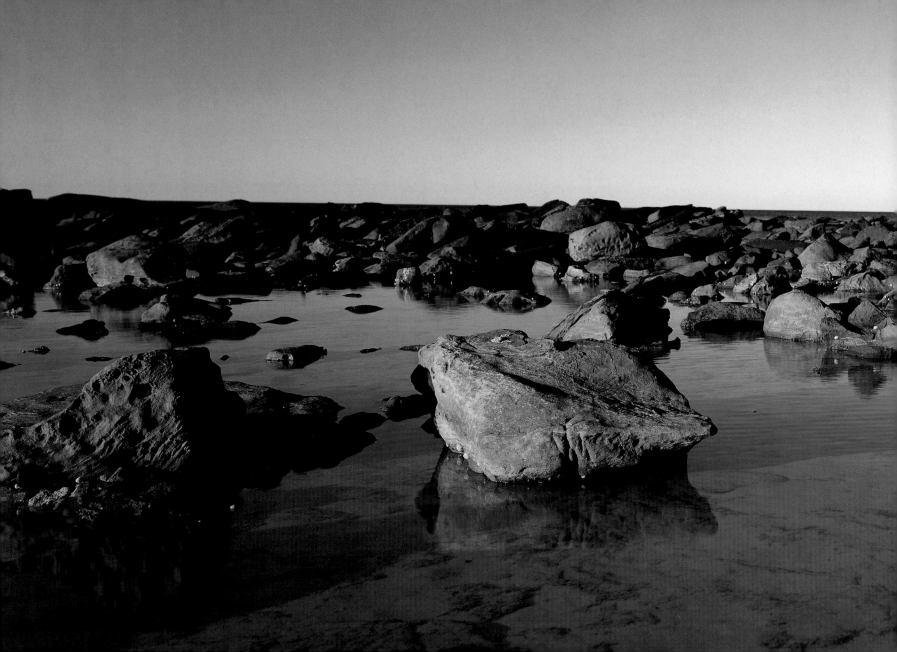

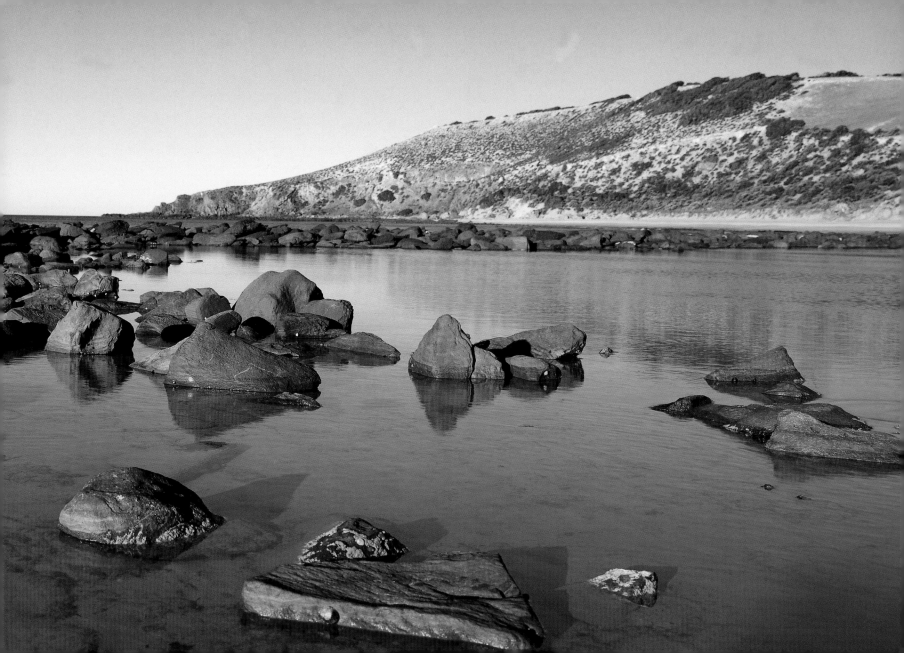

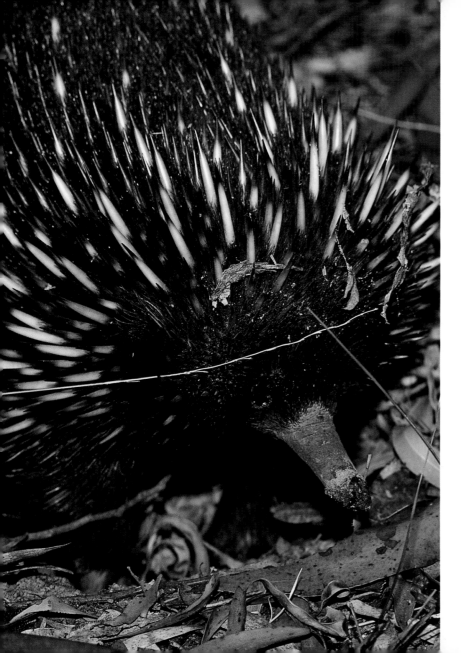

PREVIOUS PAGE : *Stokes Bay on Kangaroo Island, off South Australia. With its unspoiled wilderness areas, the island is a refuge for wildlife, including koalas, seals, platypuses and wallabies.*
LEFT : *Echidnas can be found almost everywhere in Australia. They lay eggs and suckle their young, like platypuses, and use their long sticky tongue to feed on ants.*
RIGHT : *Huge tree ferns are a feature of Mt Field National Park, one of Tasmania's oldest national parks, close to its capital, Hobart.*

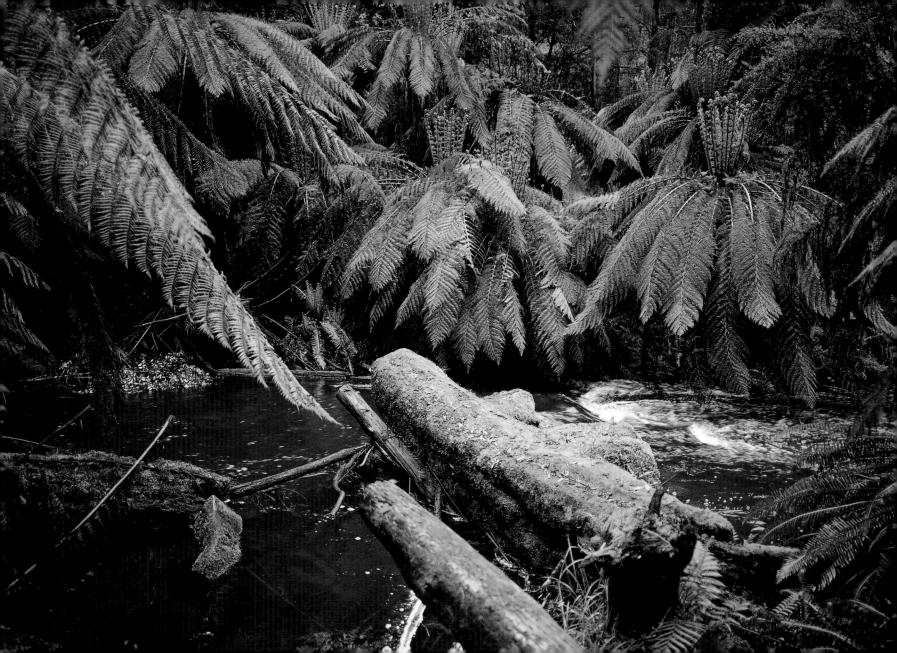

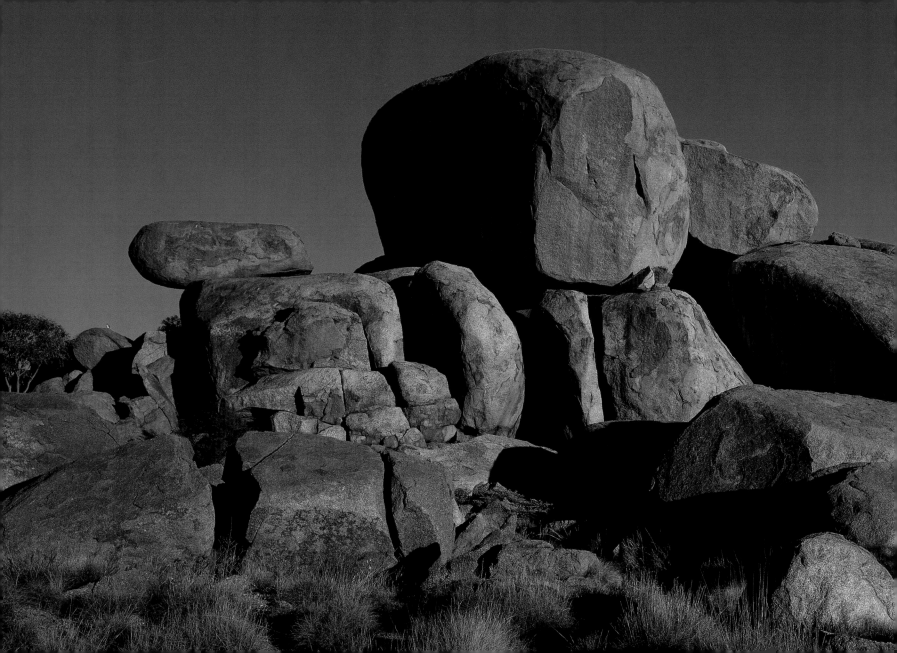

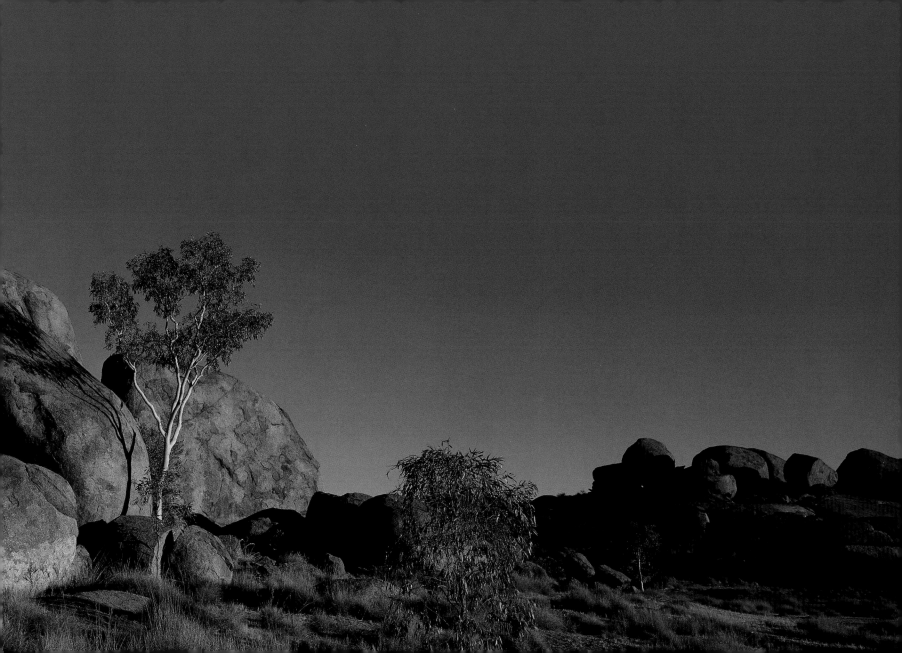

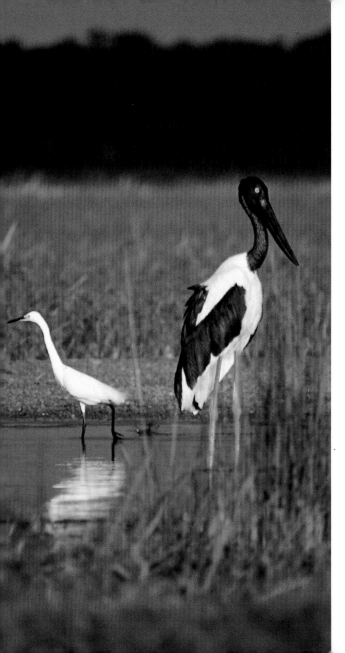

PREVIOUS PAGE : *The Devil's Marbles, an outcrop of massive granite boulders precariously piled on top of each other beside the road north of Alice Springs, are referred to in Aboriginal legend as 'the eggs of the Rainbow Serpent'. The boulders are the eroded remains of a once huge mass of granite.*

LEFT : *Waterbirds in Kakadu National Park. The impressive Black-necked Stork (right), commonly known as the Jabiru, can take prey as large as frogs and turtles in its long, powerful beak.*

RIGHT : *Tranquil wetlands in Kakadu National Park.*

NEXT PAGE : *Rain and wind across this vast dry lakebed in Mungo National Park, western New South Wales, has sculpted sand and clay into dramatic shapes, and in so doing has revealed evidence of continual Aboriginal occupation dating back over 40 000 years. Once upon a time the lake was full, and was also visited by giant kangaroos, emus and wombats, evidence of which lies in the sand.*

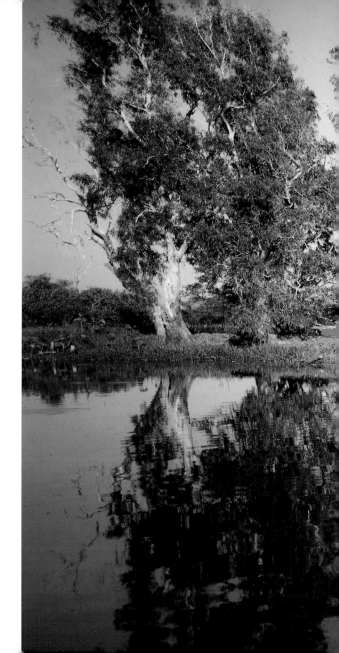

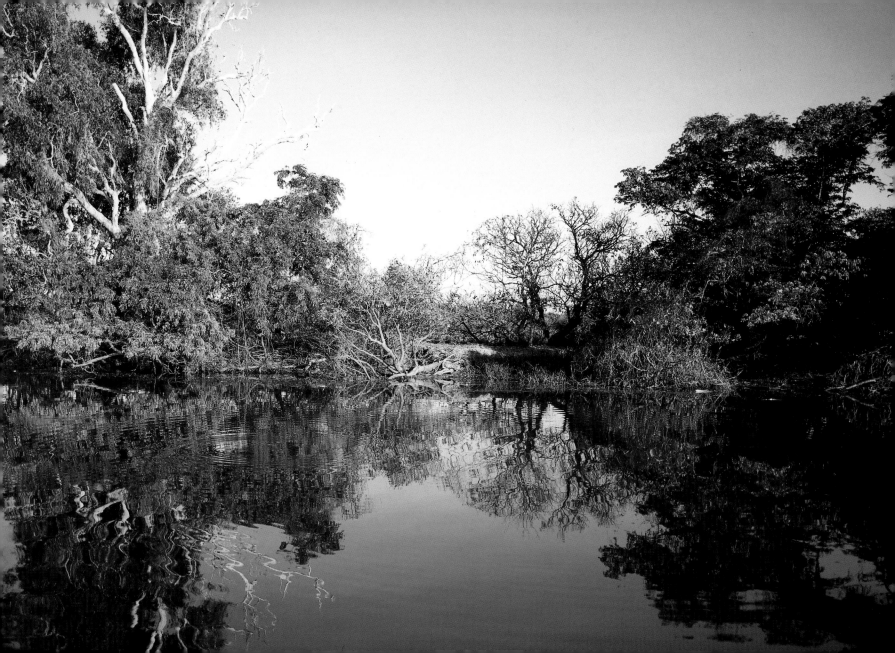

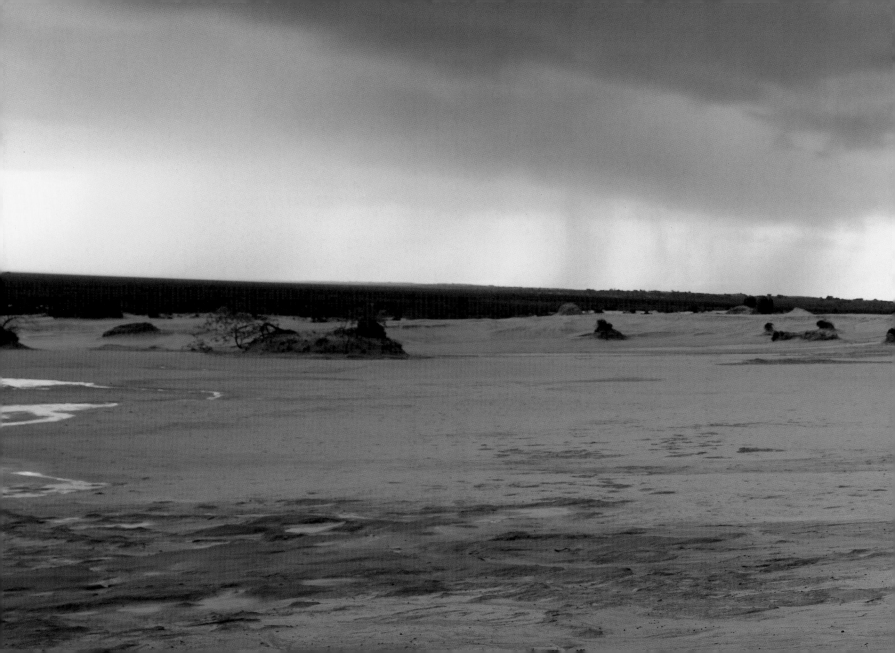

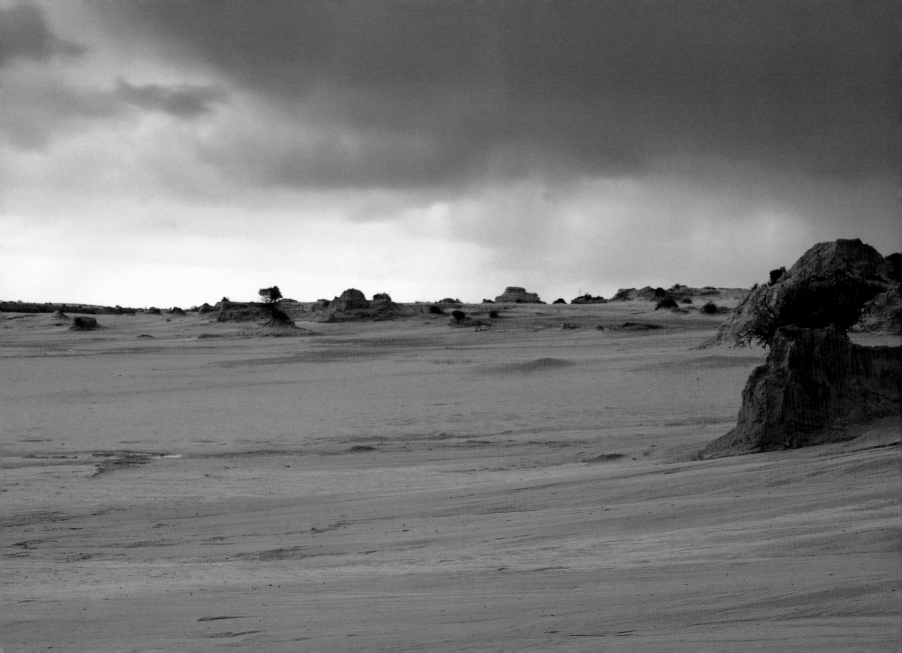

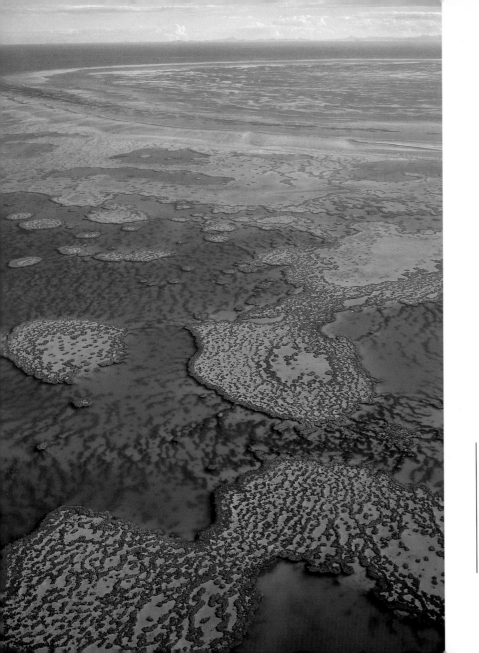

LEFT : *Coral reefs in the Whitsunday area of Queensland, part of the Great Barrier Reef, which stretches 2300 km from north of Bundaberg to the tip of Cape York.*

RIGHT : *The feathery tentacles of a fan worm, an inhabitant of coral reefs, are used to filter food from the water.*

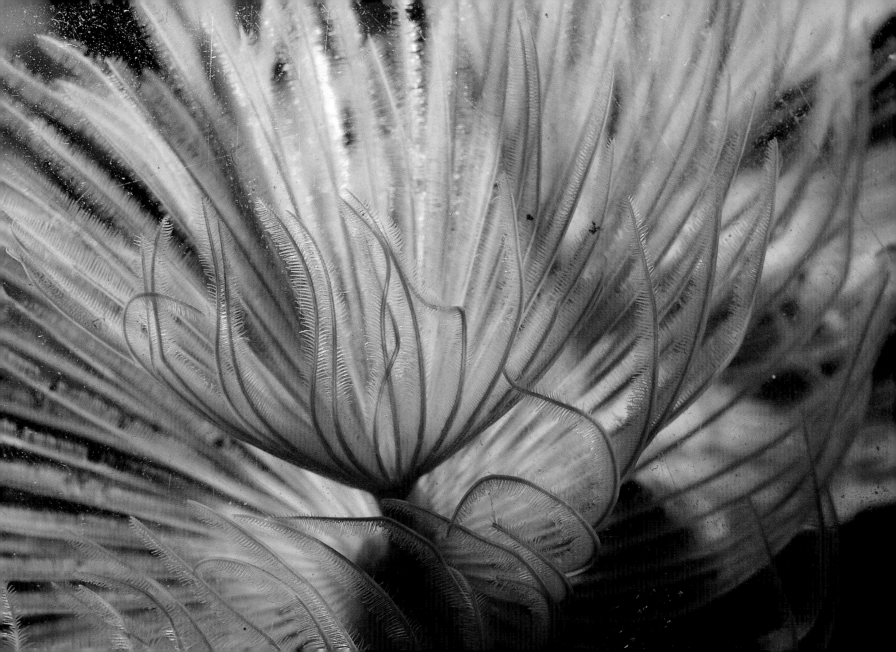

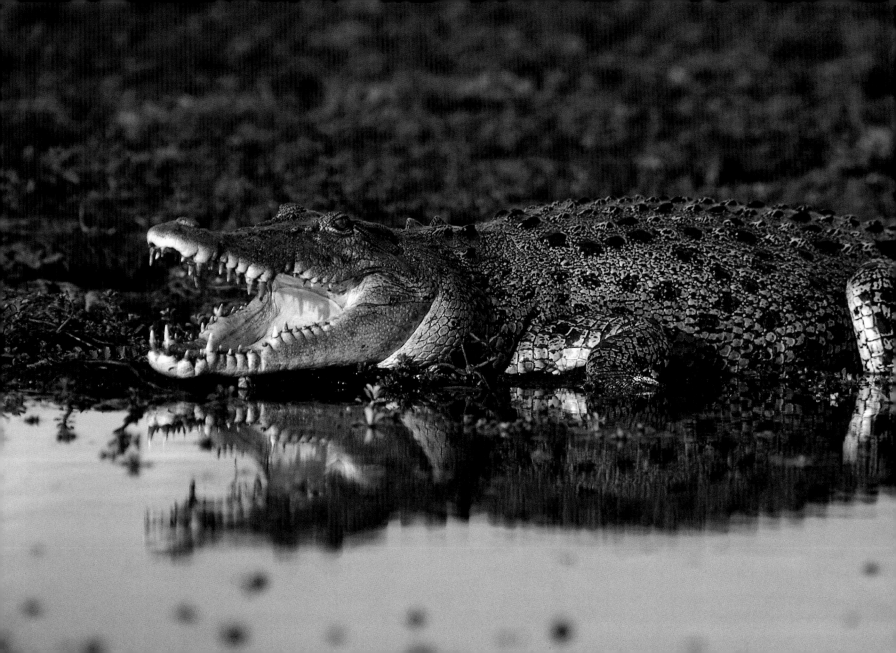

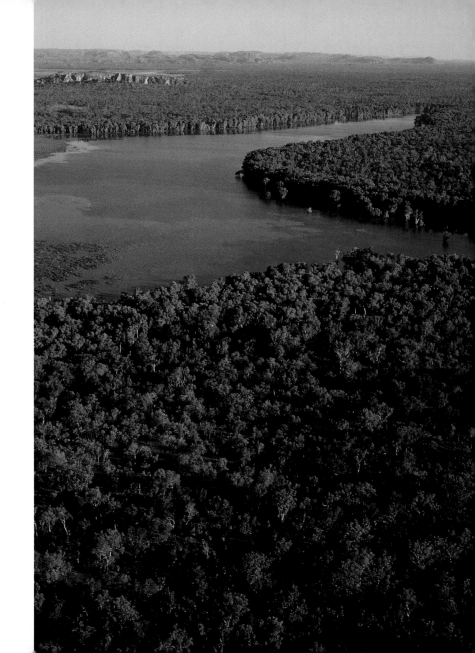

LEFT : *Deadly saltwater crocodiles are common across the north of Australia, both along the coast and in rivers, creeks and waterholes, even quite a distance inland.*

RIGHT : *Crocodile country in Arnhem Land, Northern Territory.*

NEXT PAGE : *The huge rounded domes of Kata Tjuta (The Olgas)—meaning 'many heads' in the local Aboriginal language—lie not far from Uluru in the centre of Australia. The area is sacred to men of the Anangu people.*

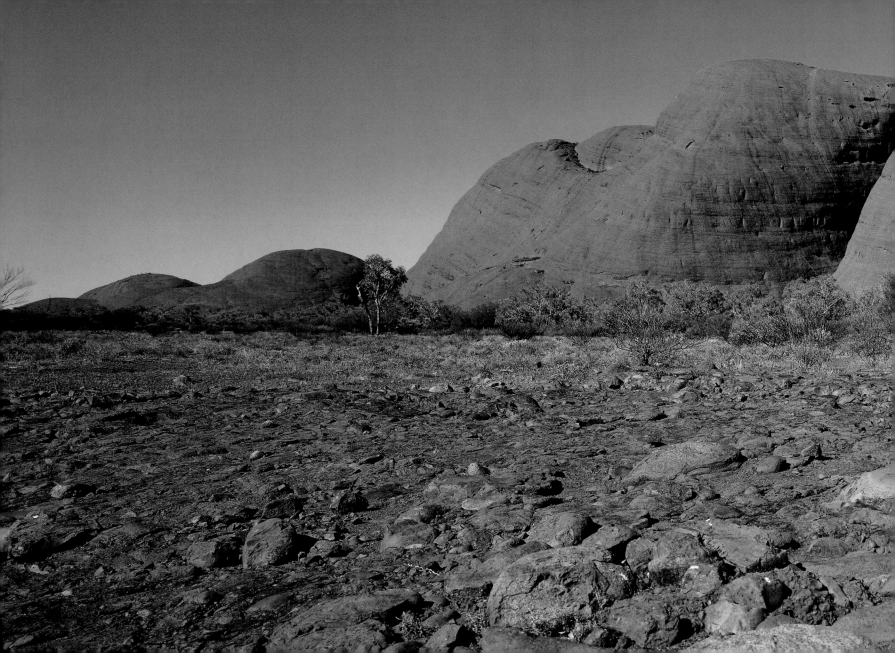

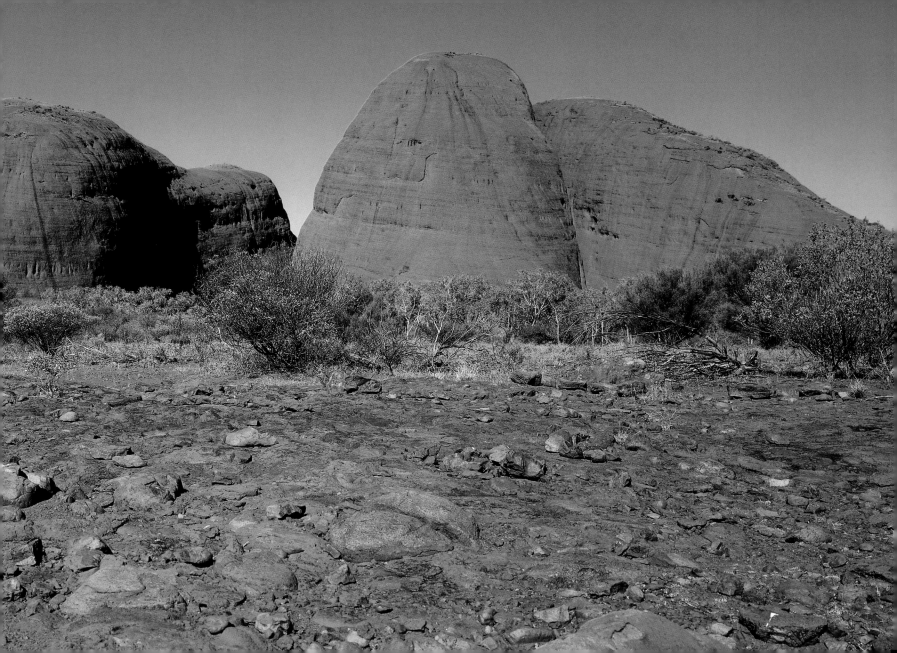

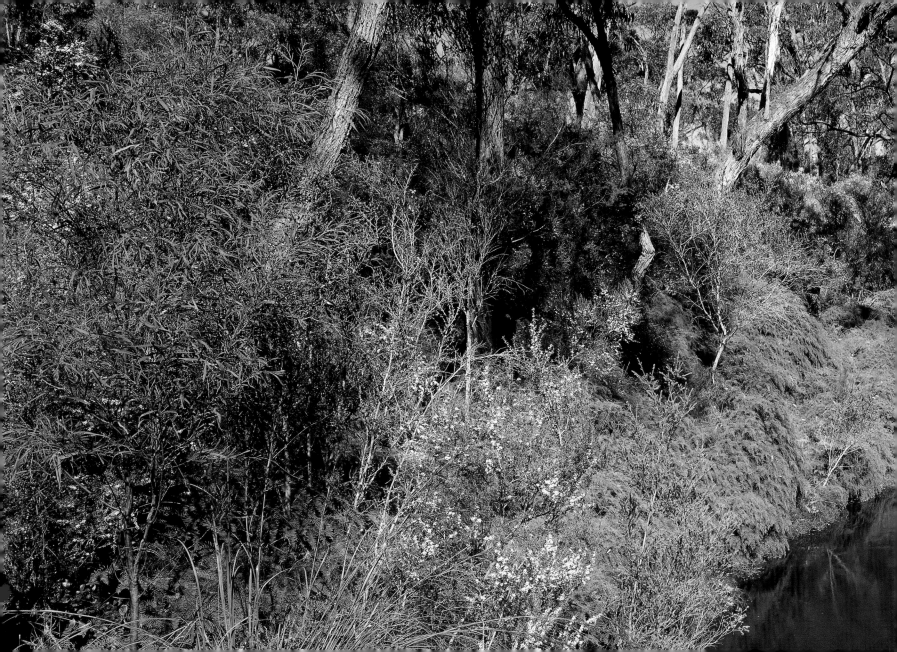

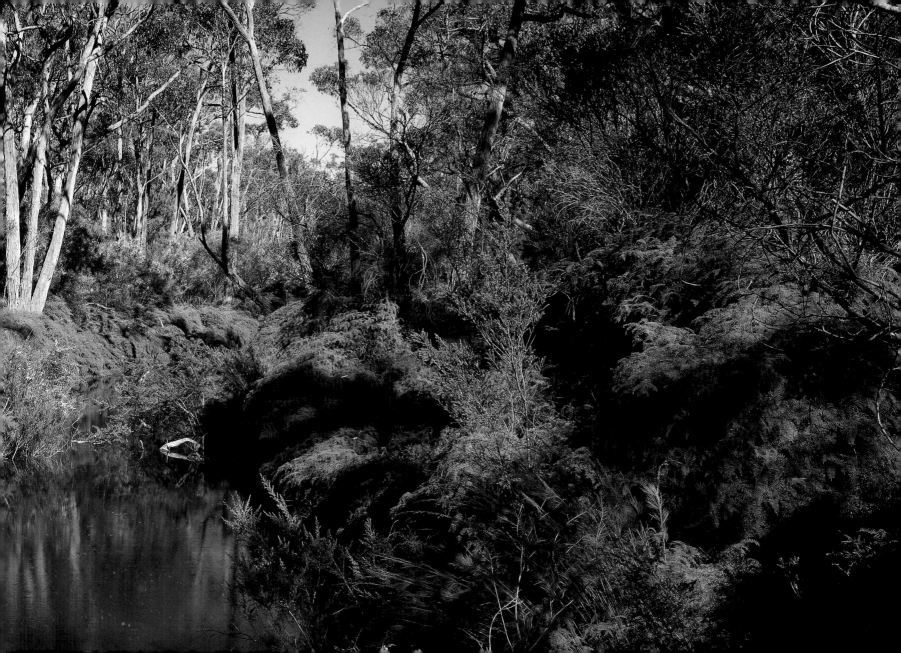

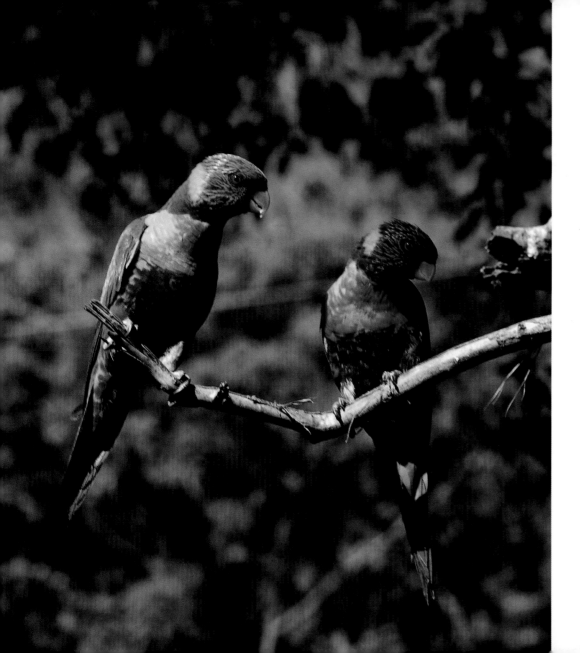

PREVIOUS PAGE : *The Alexandra River in the Grampians National Park, Victoria.*
LEFT : *Noisy Rainbow Lorikeets are common across eastern Australia, often flocking to feeding trays in wildlife parks. Their 'brush' tongues are adapted for lapping up nectar from flowers.*
RIGHT : *It has taken millions of years for the Katherine River to carve 13 natural gorges through the sandstone. Katherine Gorge, in the Northern Territory's Nitmiluk National Park, is an important site of Aboriginal X-ray art.*
NEXT PAGE : *Millstream Falls cascades over an old basalt lava flow on Queensland's Atherton Tableland. Volcanic activity continued in the area until as recently as 10 000 years ago, with more than 50 volcanoes spilling their contents over the landscape.*

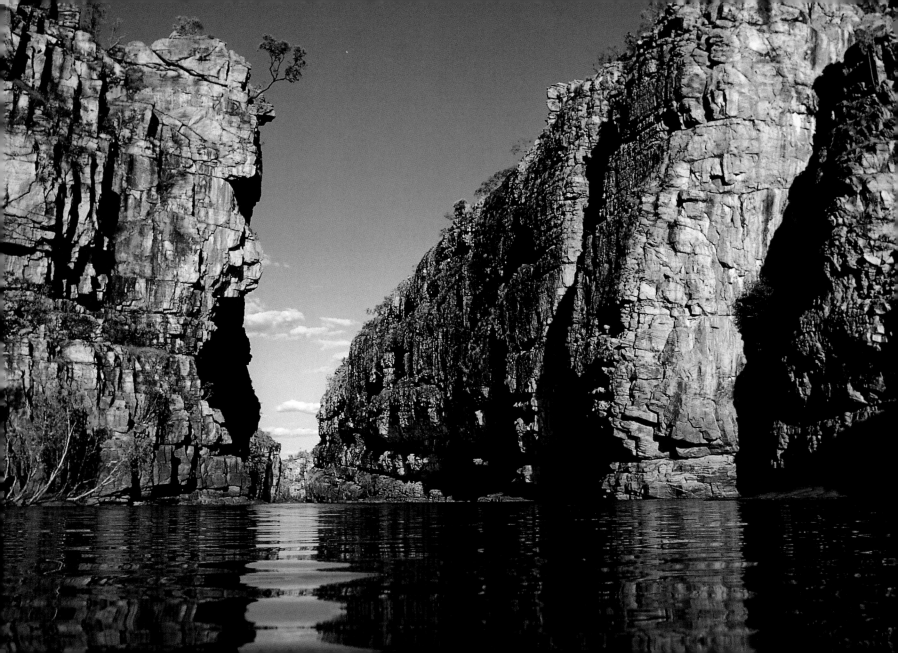

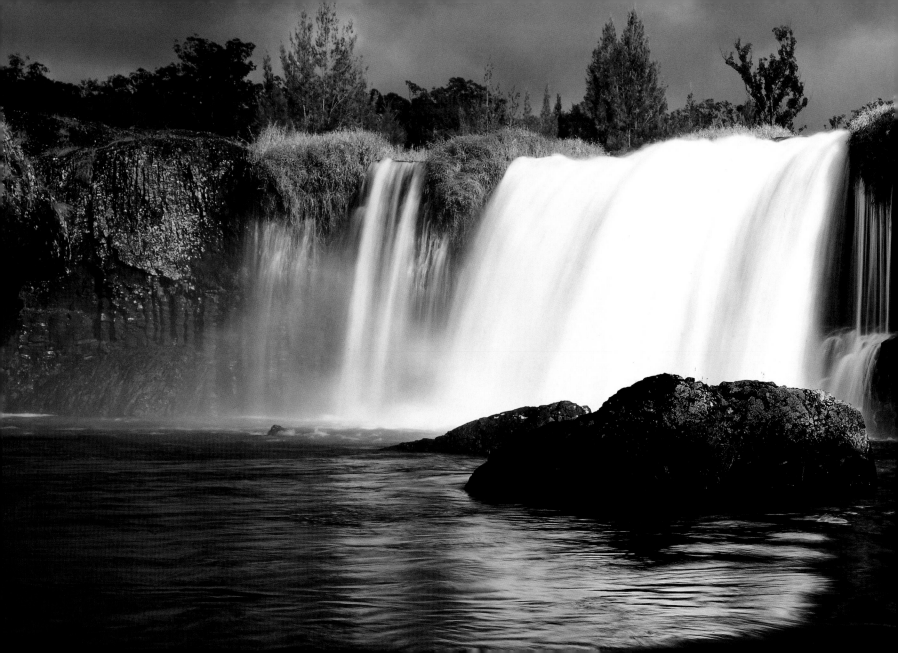

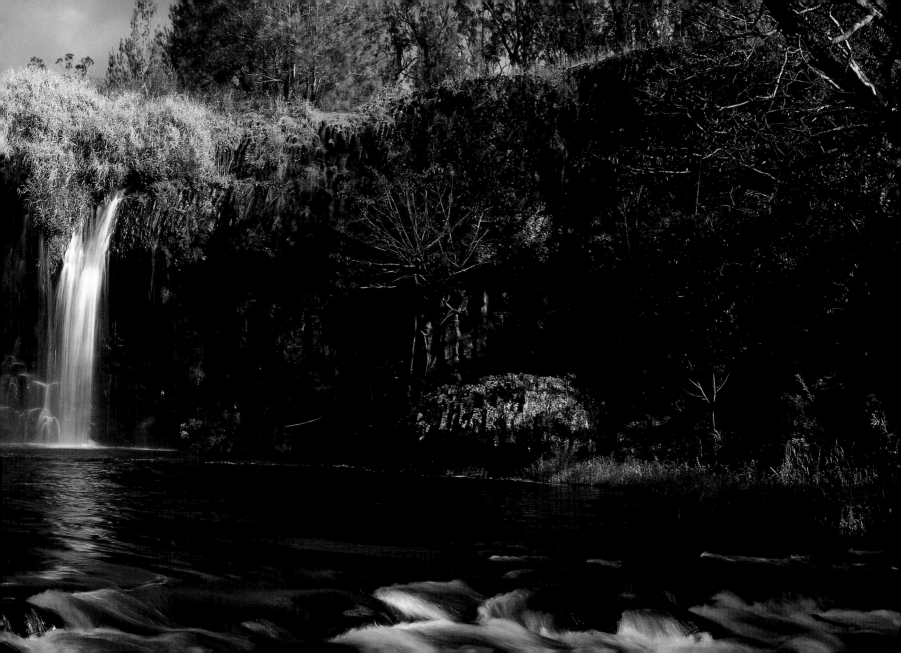

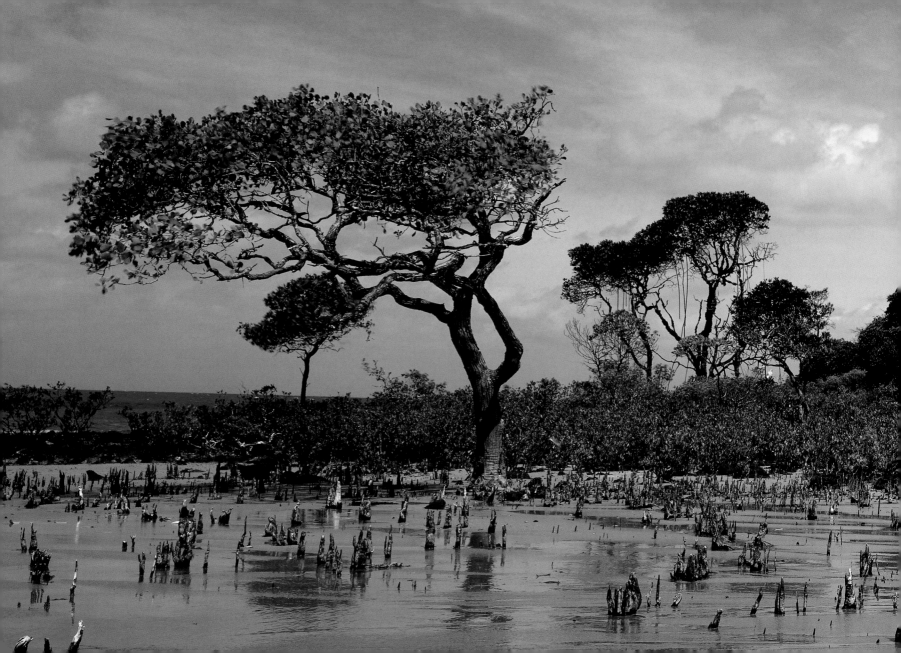

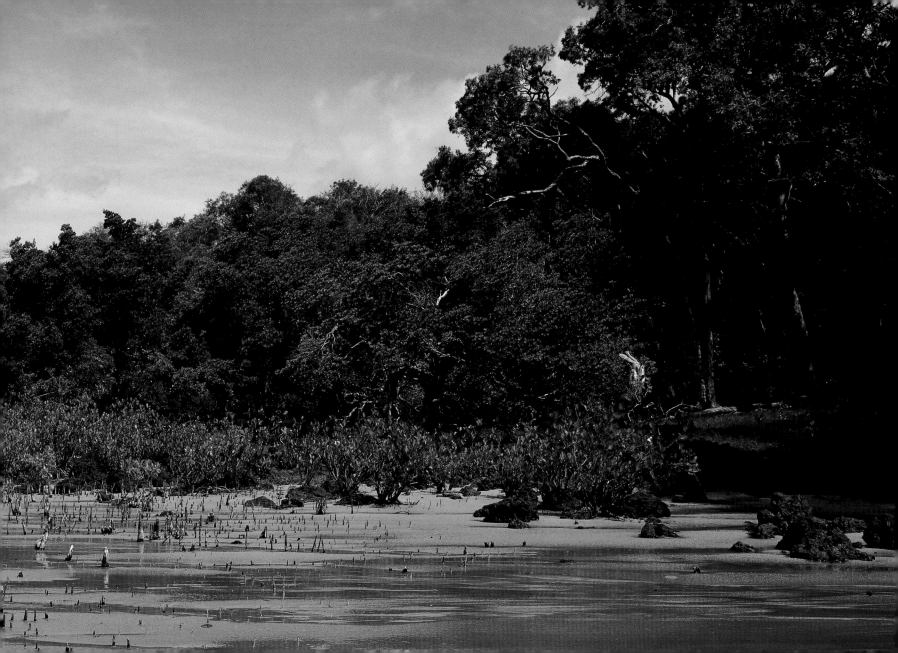

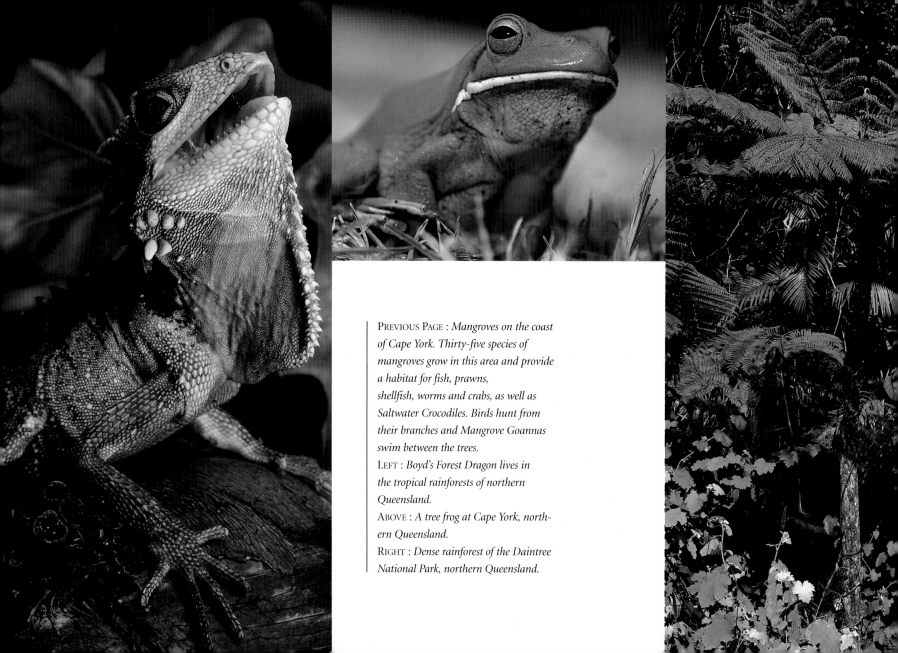

PREVIOUS PAGE : *Mangroves on the coast of Cape York. Thirty-five species of mangroves grow in this area and provide a habitat for fish, prawns, shellfish, worms and crabs, as well as Saltwater Crocodiles. Birds hunt from their branches and Mangrove Goannas swim between the trees.*

LEFT : *Boyd's Forest Dragon lives in the tropical rainforests of northern Queensland.*

ABOVE : *A tree frog at Cape York, northern Queensland.*

RIGHT : *Dense rainforest of the Daintree National Park, northern Queensland.*

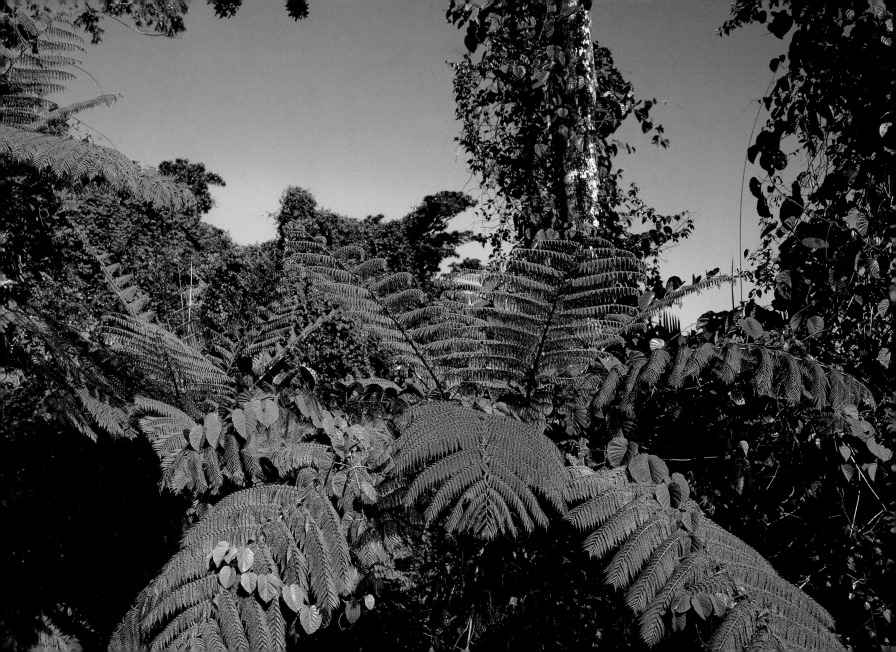

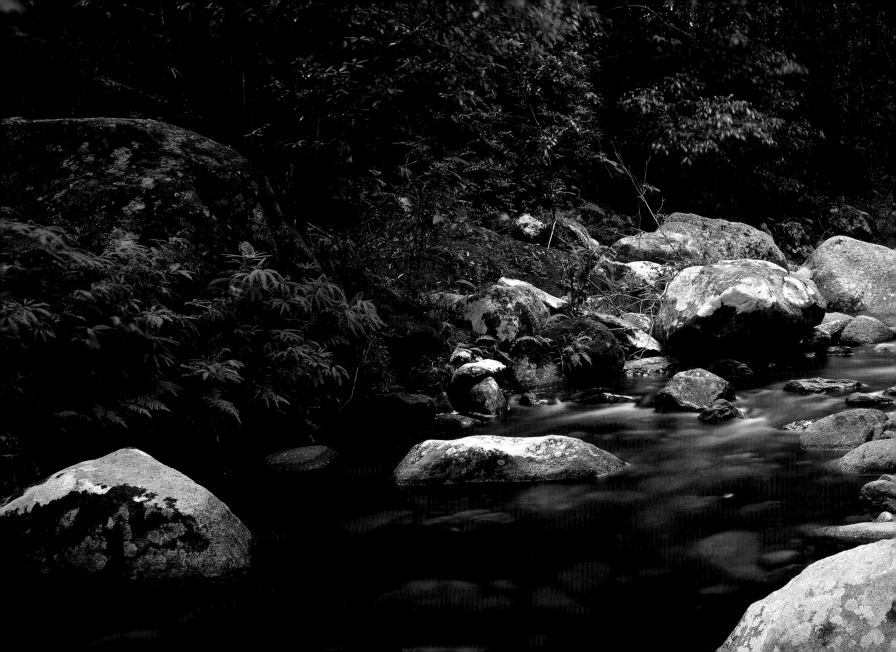

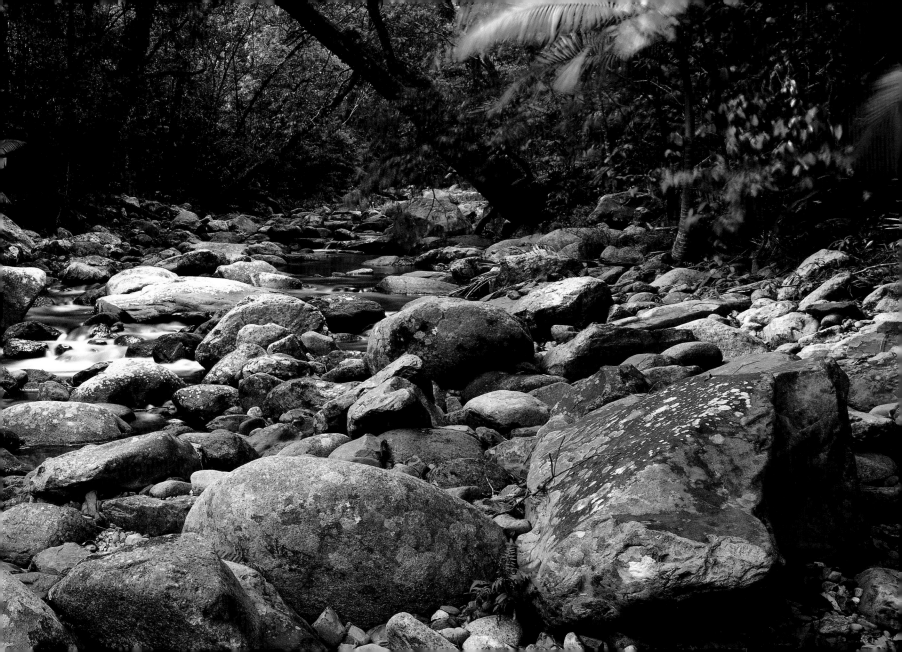

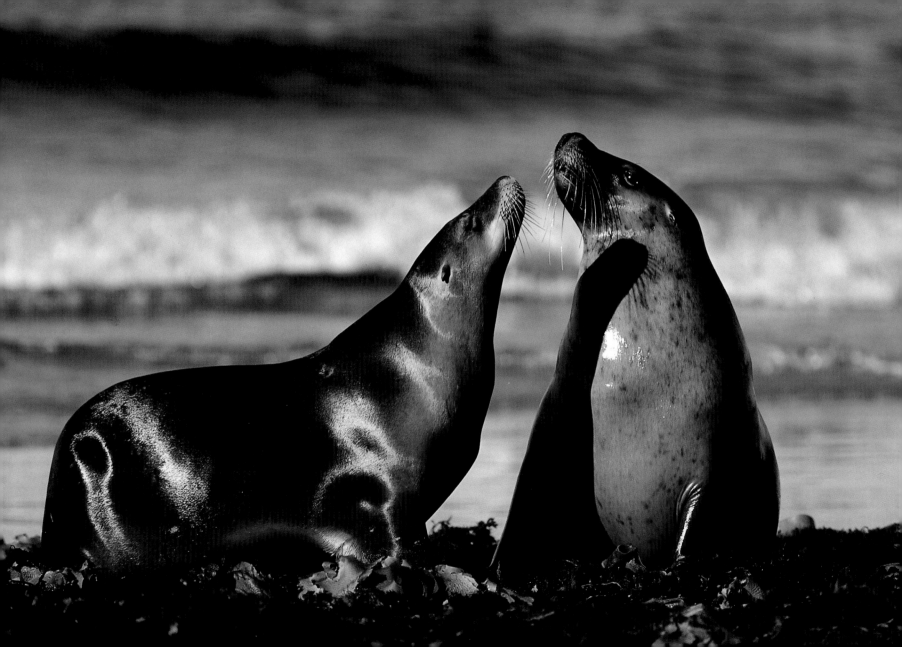

PREVIOUS PAGE : *Crystal clear waters, overhung by lush tropical rainforest, flow over large granite boulders in Mossman Gorge north of Cairns, Queensland.*

LEFT : *Australian Sea-lions at Seal Bay on Kangaroo Island, South Australia. This rare seal species occurs only in Australia.*

RIGHT : *Australian Pelicans are almost ubiquitous both around the coast and inland waterways. They soar like small planes across the skies, and gather for a free feed where fishers clean their catch.*

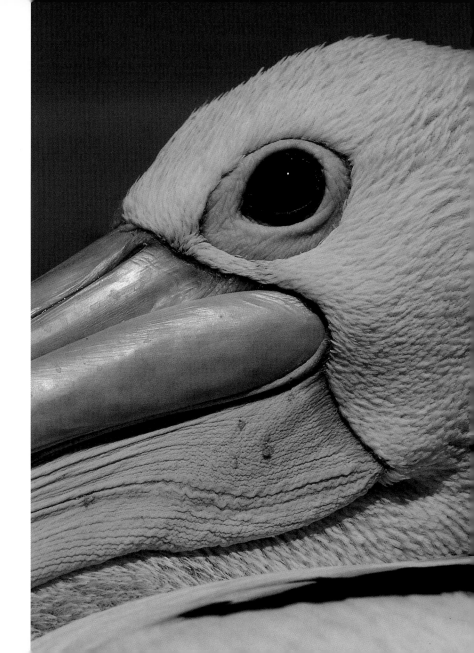

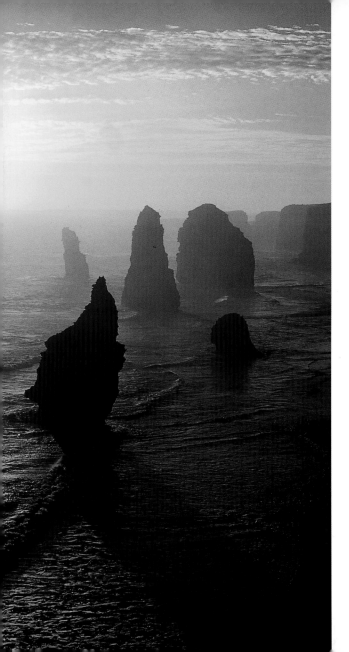

*The pounding seas of the Southern
Ocean are constantly eroding the
sandstone cliffs along Victoria's Great
Ocean Road, creating rock stacks such as
these, known as the Twelve Apostles
(LEFT), natural arches (RIGHT) and
caves. Occasionally one of them crashes
dramatically into the sea, while new
ones are continually forming.*

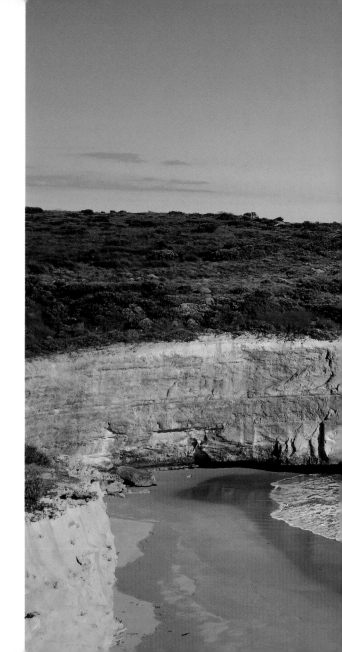

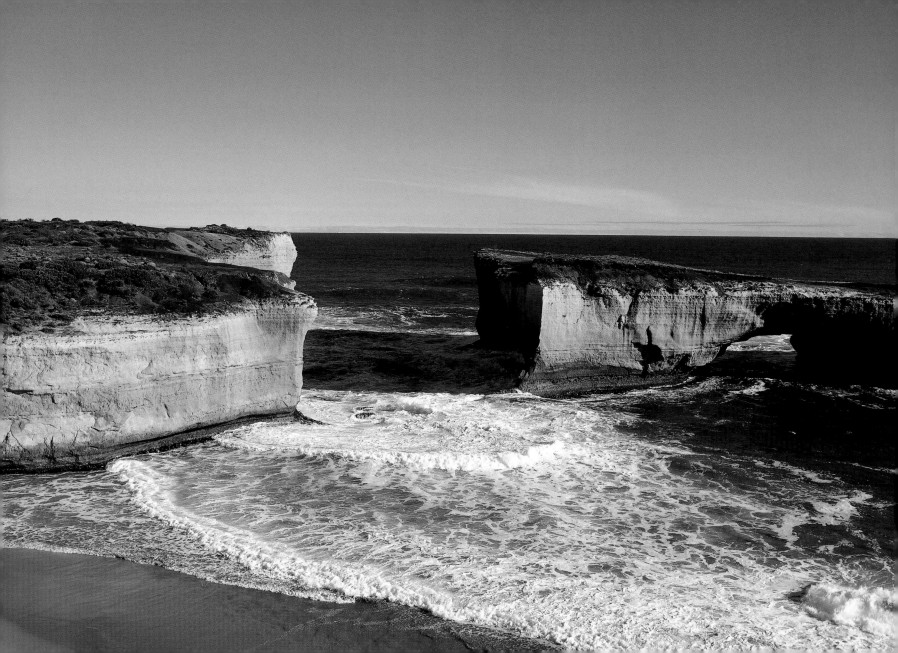

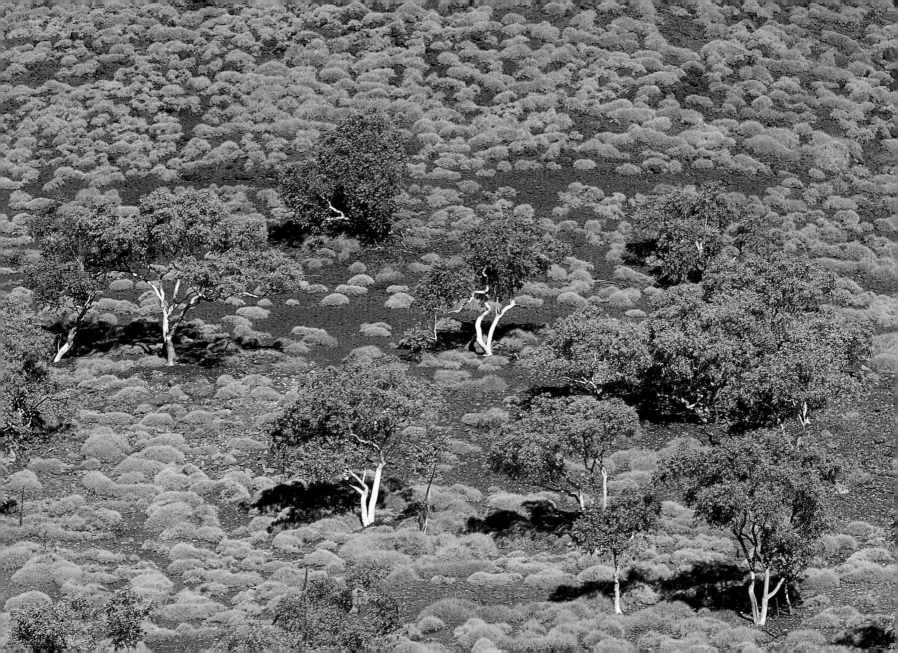

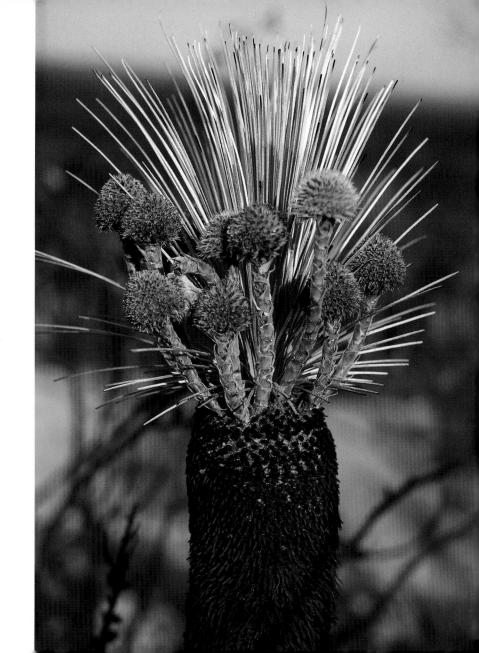

LEFT : *Ghost Gums, stony red soil and clumps of spinifex in Western Australia's Millstream–Chichester National Park, Western Australia.*

RIGHT : *The slow-growing grass tree* Kingia australis, *with its spiky, grass-like leaves, strange rounded flower heads and blackened trunk, is a feature of Western Australia.*

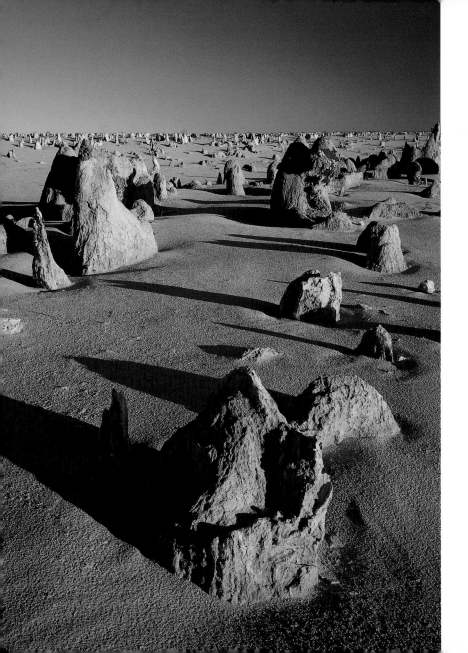

LEFT : *The Pinnacles Desert, in Western Australia's Nambung National Park. Thousands of huge limestone pillars rise out of the sand, eroded remnants of what was once a thick layer of limestone.*
RIGHT : *Rugged, rich red rocks meet the dazzling blue sea at Gantheaume Point near Broome, Western Australia. Low tide reveals ancient dinosaur footprints set in the rocks beneath the sea.*

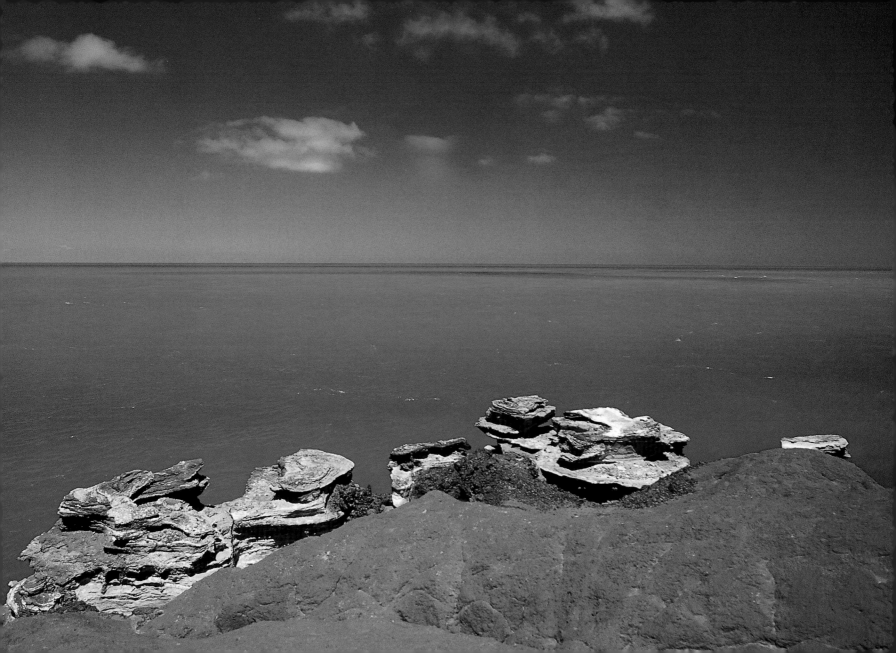

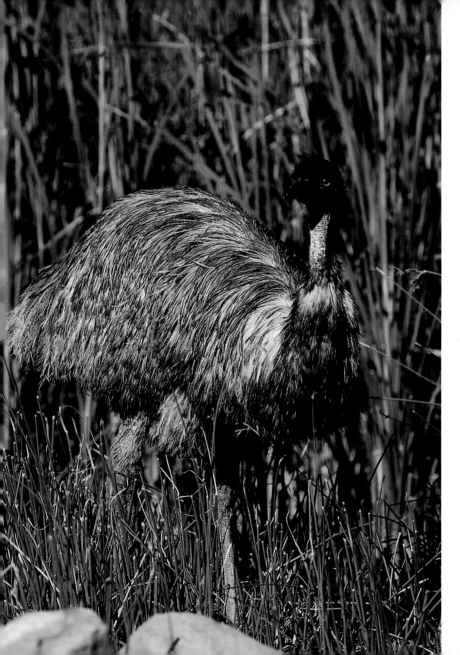

LEFT : *Emus have a reputation for eating anything, and will often scavenge among rubbish around camping and picnic areas. But their natural diet includes a wide variety of plants—flowers, seeds, fruit and/or leaves—and insects. They can run fast with huge strides and kick hard when cornered.*

RIGHT : *Hamersley Range in the Pilbara, Western Australia. The region is rich in resources, and has long been mined for iron ore, among other things.*

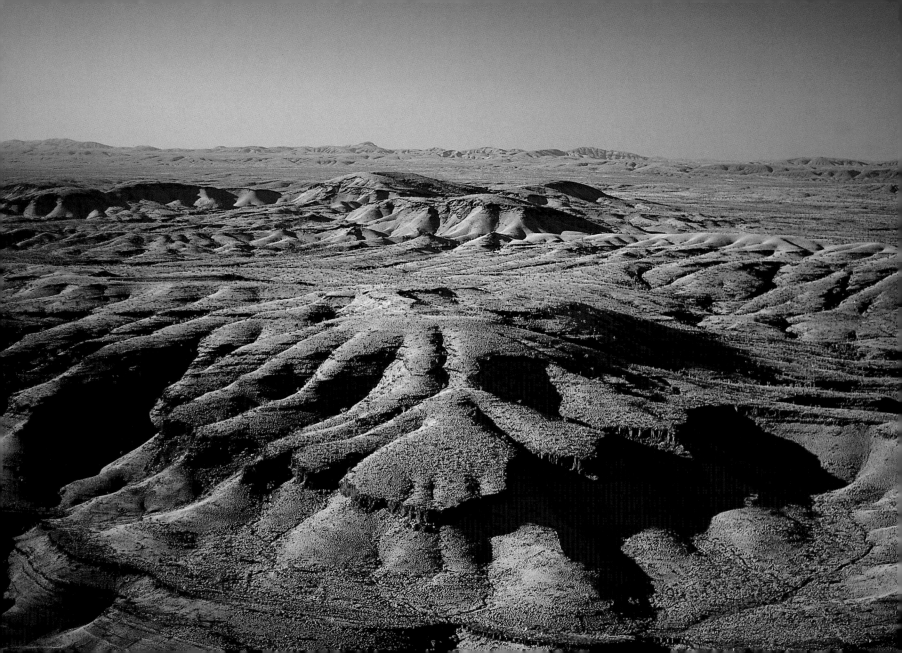

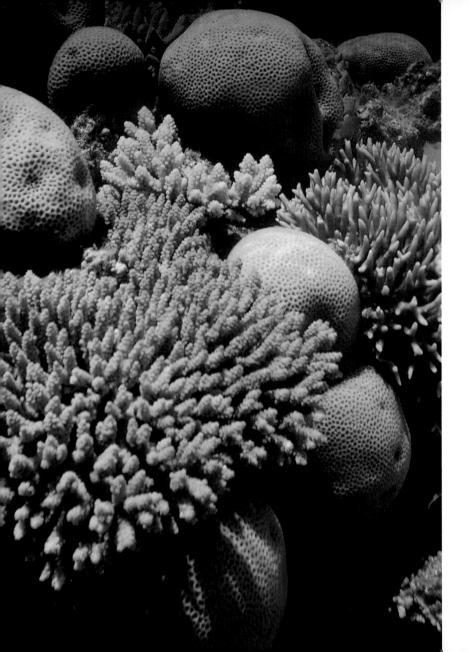

LEFT : *Corals off Lizard Island, on Queensland's Great Barrier Reef.*
RIGHT : *Dolphins are fairly ubiquitous in Australian waters and can often be seen playing in the surf or riding the prow wave of a boat.*
NEXT PAGE : *The view across to Point Ann, Fitzgerald River National Park, Western Australia. The park is known for its spongelite cliffs, named for the silica skeletons of sponges contained in the sedimentary rocks, and for its spectacular scenery and wildflowers. In the foreground is a Southern Right Whale and calf.*

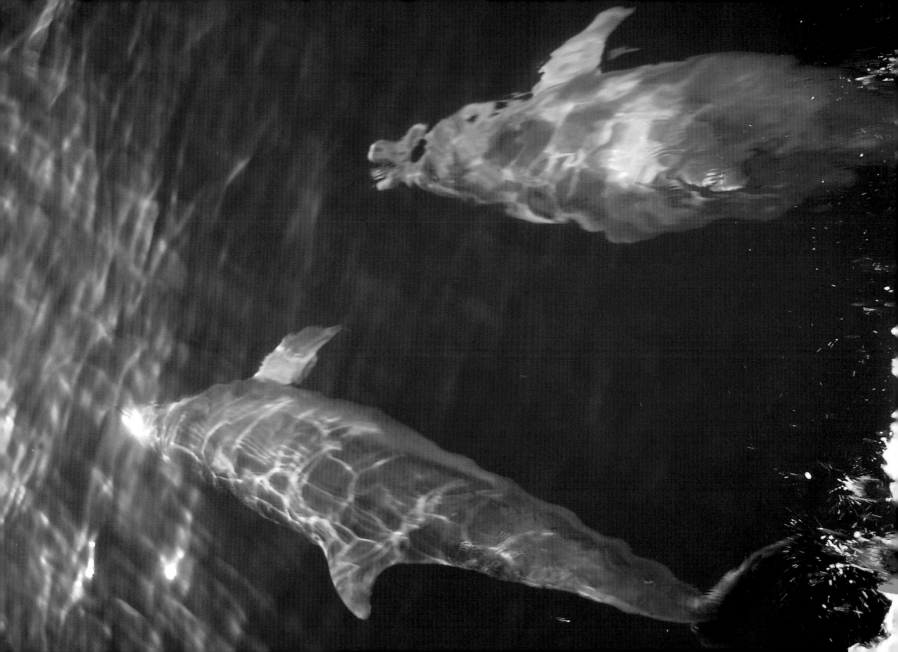

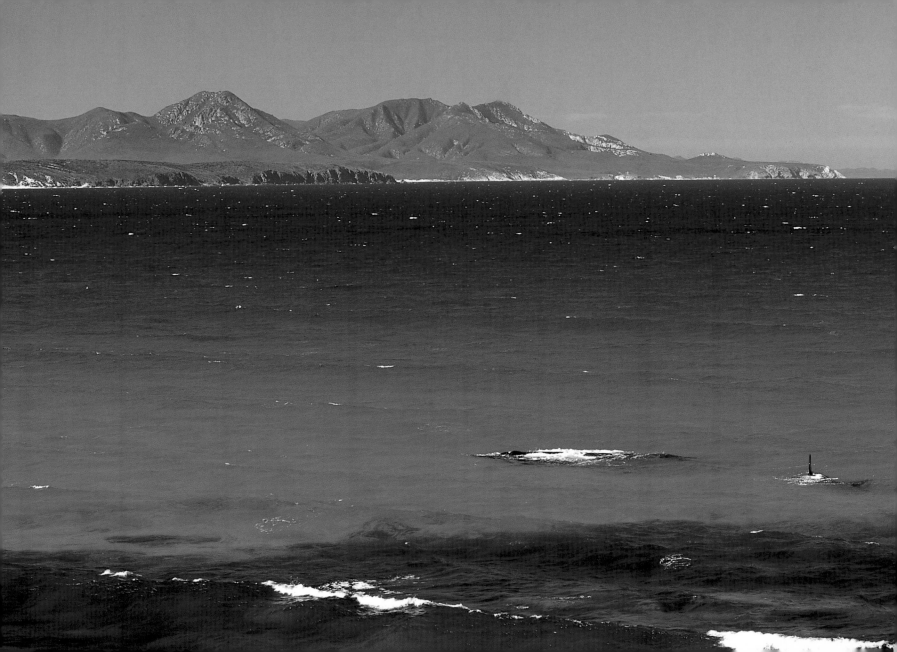

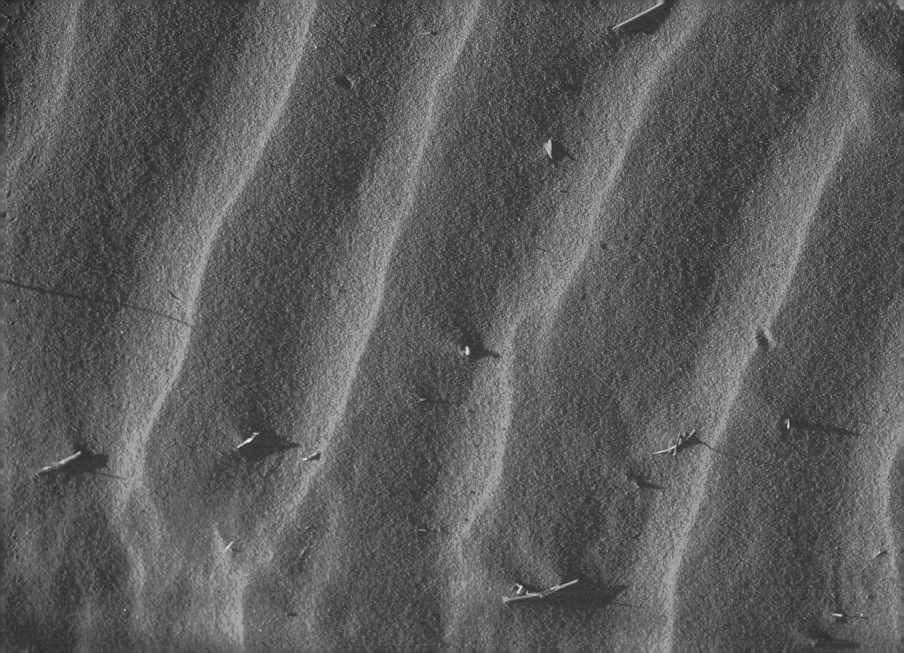